IMAGES
of America

MARINE CITY

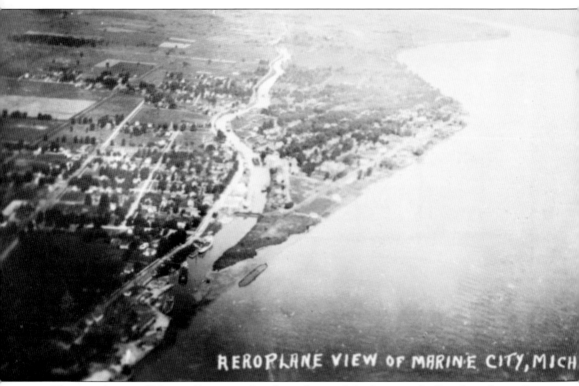

AEROPLANE VIEW OF MARINE CITY, MICH

This aerial view of Marine City was taken from the south looking north. Based on the spelling of "aeroplane," this photograph dates to the early 1920s. (Courtesy of Gene Buel.)

ON THE COVER: This photograph shows a group of shipwrights and builders working on one of the many wooden steamers built on the Belle River. (Courtesy of Gene Buel.)

IMAGES
of America

MARINE CITY

Gene Buel and Scott Buel

ARCADIA
PUBLISHING

Published by Arcadia Publishing
Charleston, South Carolina

Printed in the United States of America

Library of Congress Control Number: 2012935502

For all general information, please contact Arcadia Publishing:
Telephone 843-853-2070
Fax 843-853-0044
E-mail sales@arcadiapublishing.com
For customer service and orders:
Toll-Free 1-888-313-2665

Visit us on the Internet at www.arcadiapublishing.com

Dedicated to the memory of our dear family friend, Mr. Gareth L. McNabb (1941–2011). Without his passion for this subject matter, or his work on A Short History of Marine City, *this book would not have been possible.*

CONTENTS

ACKNOWLEDGMENTS

Thanks go to the Marine City Pride and Heritage Museum, especially its president, Gary Beals, who has been instrumental in our research. We'd also like to thank our wives, Jeanie and Amanda Buel, for their love, patience, and support during the writing of this book. Thanks to Jeanie for her patience over the past 50 years of Gene's collecting the pictures that make up this book. Thanks to Amanda for helping Scott by being an excellent editor and critic. We thank you, and we love you both. Unless otherwise noted, all images appear courtesy of Gene Buel.

INTRODUCTION

Not a large city like Detroit to the south or Port Huron to the north, Marine City has a historical significance in the Great Lakes maritime story and deserves recognition for its place in the history of the state of Michigan, as well as in American history. This is not a rote retelling of historical facts already covered by works such as A. T. Andreas's *History of St. Clair County Michigan* (1883), William Jenks's *St. Clair County Michigan: Its History and Its People* (1912), and *A Short History of Marine City* (printed 1980) as told by Frank McElroy to the Marine City Rotary Club in 1929. Instead, this is a look back in time captured in photographs that show the spirit of the people who made Marine City what it is—a distinctly American community with deep working-class roots. This is Marine City through the lens of early photography, from the 1870s through the 1930s.

However, since every good story must have a beginning, here is the condensed tale of how Marine City became Marine City. The area of modern-day Marine City had been Ojibwa territory for centuries before the first Europeans made contact. French fur trappers and Catholic missionaries settled in Detroit during the Colonial period, slowly moving their settlements north into the wilderness. In the 1780s, the area's first Europeans—French, Austrian, and German families—settled on farms below the mouth of the Belle River in what would become Cottrellville Township after 1822. From there, the populace spread north along the Belle and St. Clair Rivers. The French called the area La Belle Reire, or Belle River, while English speakers called the community Yankee Point, probably because many of the settlers migrated from New England.

When Capt. Samuel Ward arrived here on a trading expedition in 1818, James Monroe was America's fifth president, "Old Glory" donned only 22 stars, and Michigan would not be admitted to the Union for another 19 years. In 1819, Ward built a log home on what is now Water Street. He moved his family from Conneaut, Ohio, navigating Lake Erie in his schooner, the *Salem Packet*. For a brief time after their arrival, the area was known as "Ward's Landing."

In 1820, Ward built a shipyard on the St. Clair River at the foot of present-day Broadway, where he built the schooner *St. Clair*. She was put into service along with the *Salem Packet* peddling pumpkins, potatoes, whiskey, and other produce and merchandise along the shores of the lakes.

The Erie Canal officially opened on October 26, 1825. It was the first transportation system between the Eastern Seaboard and the Great Lakes that did not require portage or carts pulled by draft animals. In 1826, Ward set out for New York City, with the *St. Clair* carrying skins, furs, potash, and black walnut lumber for use in gun stocks. This was the first vessel to pass from the Great Lakes to the Atlantic Ocean via the Erie Canal. Ward continued in the shipbuilding industry until his death and was popularly known as the "Commodore of the Lakes." His fleet included seven sailing vessels and 23 steamers.

When St. Clair County was established in 1821, Ward attempted to make Belle River the county seat but lost out to St. Clair. In 1831, he successfully established a post office and was appointed its postmaster. In 1834, Ward plated the village as Newport, and it held that name for

31 years. In 1865, it was incorporated as the village of Marine City. In 1887, thirty-three years after Ward's death, the village reincorporated as a city. Capt. Samuel Ward can truly be considered the founding father of Marine City.

By the 1870s, shipyards in Marine City employed hundreds of men with good wages and produced an estimated 243 wooden-hulled ships—schooners, steamboats, tugs, and every kind of vessel in between. As expected, with ships came sailors. According to the 1890 annual review edition of the *Marine City Magnate*, "Sailors constitute a large percentage of our citizens; and it is possible that no city on the chain of lakes turns out as large a percentage of sailors as may be found from Marine City."

In 1874, Marine City experienced another boom with Crocket McElroy's discovery of rock salt. This discovery made the entire salt industry in Michigan's Thumb possible. Over the years, 13 different salt companies produced rock salt here, many owned by former shipbuilders.

In 1892, steel-hulled ships usurped the demand for the construction of wooden vessels. With no direct railroad line to bring iron in, combined with shallow launching sites on the Belle River, the shipbuilding industry diminished. However, the town still remained an important stop for the lake steamers that relied upon wood for fuel supplied by the local lumber industry, as coal had not yet come into use.

In 1900, Marine City became home to one of the first "modern" photographers to document the Great Lakes shipping industry at the turn of the 20th century: Louis Pesha. (Of historical note: the earliest-known photograph of a Great Lakes vessel is a Daguerreotype of the steamer *Mayflower*, taken 40-some years before Pesha plied his trade.) Additionally, he left behind an important photographic register of the turn of the century, capturing everything from railroad stations to street scenes to everyday moments of life. Over 100 years later, Pesha's work helps tell the story of this city, its industry, and most importantly, its people.

One

MARINE CITY
THROUGH THE AGES
1870s–1930s

According to *A Short History of Marine City*, "The men wore whiskers and the women wore hoopskirts. Men were still wearing boots, and women high laced shoes." In 1874, Marine City's first newspaper, *The Marine City Gazette*, was published, and the first bank in town, the Marine Bank of Holbert and Westcott, was established. Wooden sidewalks and gasoline-powered streetlights lined dirt streets. Water was hauled in two-wheeled drays from the St. Clair River to residents with no wells. Until 1899, when it was destroyed by fire, children attended the Union School. Butter cost 16¢ a pound, eggs 10¢ per dozen, and a dressed chicken could be had for 8¢ a pound.

The Detroit and St. Clair River Railroad was established in 1897, bringing visitors to the local hotels and salt baths, as well as for boating, fishing, and swimming. There were, at various times, three operating sawmills, all due to the natural abundance of white oak in the area. Ship captains and shipbuilders constructed beautiful wooden and brick homes. The 1900s brought the first paved roads and cement sidewalks. The lumber industry faded and the sugar beet industry blossomed. By 1901, the population swelled to 3,829, city hall and the waterworks were completed, and there were three schoolhouses and a volunteer fire department consisting of 80 men, each receiving a salary of $5 a year. The town had a city marshal, one deputy sheriff, and three constables. In 1906, the Edison Electric Light Company was awarded a 30-year contract to install and maintain electric streetlights. Marine City was growing and changing. As time marched on, the town would witness even more interesting events, thriving through the happiness of the Roaring Twenties and the lawlessness of Prohibition.

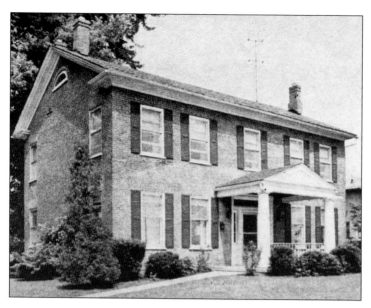

One of the five oldest houses in Michigan and the oldest brick house north of Detroit, this Greek Revival–style home was built on North Main Street around 1832 by Samuel Ward using locally manufactured bricks. The house was constructed complete with a "devil's trap" intended to deter evil spirits from entering the house through the attic window. The Holland family owned the home for over 100 years.

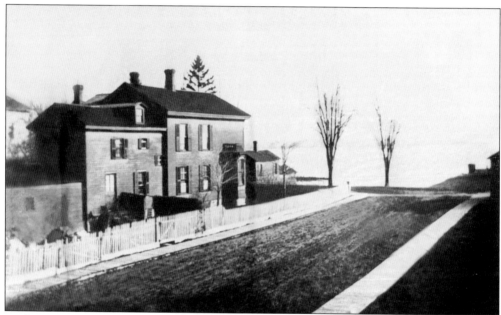

Looking east from Market Street toward the St. Clair River, this photograph shows Dr. Leonard B. Parker's residence on the northwest corner of South Water and Union Streets in 1887. Parker settled in Newport in 1846. Through the years, he owned a lumber mill on the Belle River, had ownership in sailing vessels, served as a state senator, was president of the village, was the director of the Union School, was the chief of the Marine City Fire Department, and established the first medical society in St. Clair County. It is said that he was a man of large stature, had a tremendous endurance and strength, and, according to *St. Clair County, Michigan, Its History and Its People*, was able to reach patients at long distances over "the worst of roads and through the severest of weather." He must have been a striking character because, besides being of large build, he "dressed in the old-school fashion, wearing a blue swallow-tailed coat with large brass buttons and a tall stiff hat covered with long white fur—an 'Uncle Sam' hat."

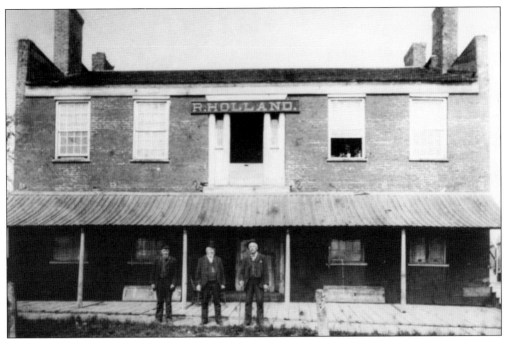

Standing in front of the R. Holland Building at 124 South Water Street on the St. Clair River are, from left to right, prominent shipbuilder Alexander Anderson, real estate man and shipbuilder Robert R. Holland, and an unidentified local man. Holland was born in this house (for many years known as "The Mansion") built by Eber Brock (E.B.) Ward. Ward was founding father Samuel Ward's nephew, president of the Flint and Pere Marquette Railroad Company, and an early lumber mogul and industrial capitalist. In the latter part of his life, Ward was known as "The Steel King of America."

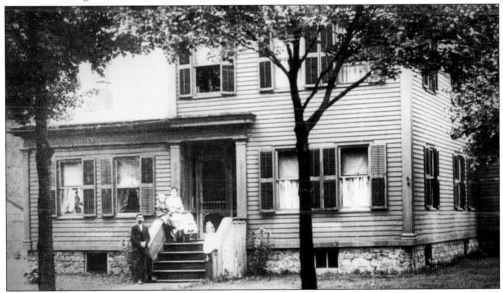

Mr. and Mrs. John Weng and their children pose on the porch of their home on South Main and Jefferson Streets. The house was formerly the home of Capt. Alexander Anderson. Weng owned the boot and shoe shop on Water Street.

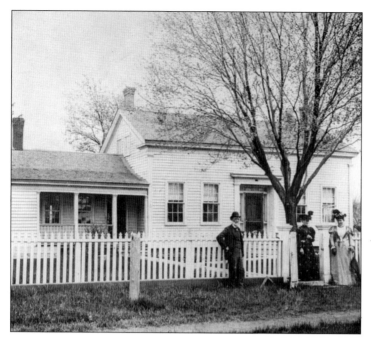

Unidentified members of the Cottrell clan pose in front of the old homestead at Avalon Beach in Cottrellville Township sometime in the late 1800s. The surname is one of the oldest in the area; the township was named in honor of George Cottrell, one of the area's first settlers. The Cottrells were sailors aboard ships such as the *Huron*, with Capt. E.B. Ward, and served in important offices such as ensign of the territorial militia as appointed by Gov. Lewis Cass.

The Wonsey home was on South Belle River Avenue and Bowery Street across from the McLouth Shipyard. John Wonsey came to Marine City in 1845 and through the years owned a sawmill, a flour mill, and farmed. In 1876, he succeeded in tapping a gas pocket at a depth of 150 feet by laying down four-inch iron pipes and connecting them to a pipe in the street. He then lit the gas, thus creating Marine City's first gas streetlight. His daughter Mary married Sydney C. McLouth of the Michigan Salt Works and the McLouth Shipyard in 1887.

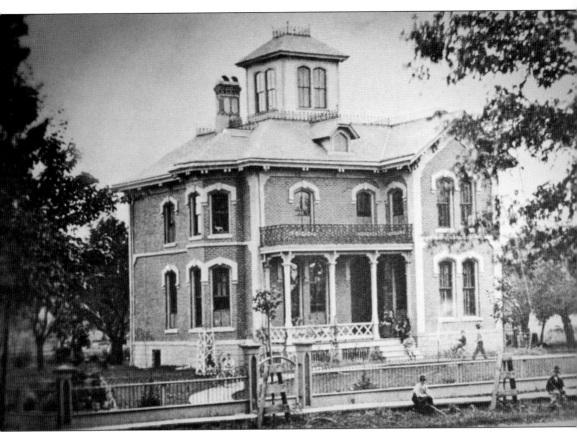

Capt. Benjamin Franklin Owen's residence, on the southeast corner of South Main and Washington Streets, was built in 1878 and was later destroyed by fire in 1910. Owen came to Marine City in 1836 and married to Abba Ward, daughter of Eber Ward and sister of "Aunt" Emily Ward of Newport Academy fame. In 1835–1836, Owen built the schooner *General Harrison*. His son Benjamin went on to become a renowned doctor, a professor at the Detroit Medical College, and author of a book about Sir Francis Bacon titled *Cipher Story*.

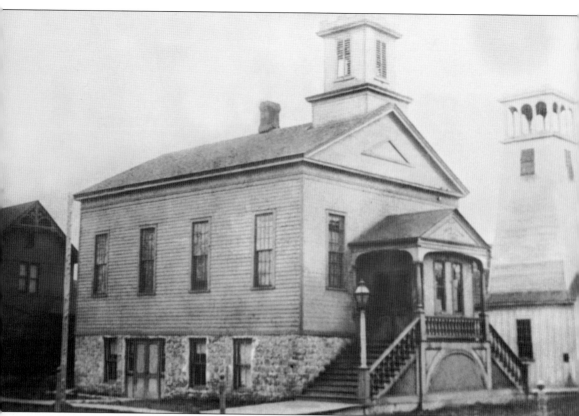

Marine City's history of education begins with "Aunt" Emily Ward, sister of E.B. Ward and niece of Samuel Ward. Before a school was built, Emily founded her Newport Academy in 1847 and acted as "Head Mistress." In the *Autobiography of Emily Ward*, the academy is described: "Any of the village children could go by paying a small fee, three dollars a year with twenty-five cents added if the student pursued the study of languages. Chemistry, astronomy, physiology, philosophy, Latin, higher mathematics and all the things required in preparation for college were taught." Originally standing at South Main and Washington Streets, the city bought and moved the building in 1869 to South Main and St. Clair Streets. Over the years, it was used as a town hall and jail, a Presbyterian church, and a city library. Since 1985, it has been the home of the Marine City Pride and Heritage Museum.

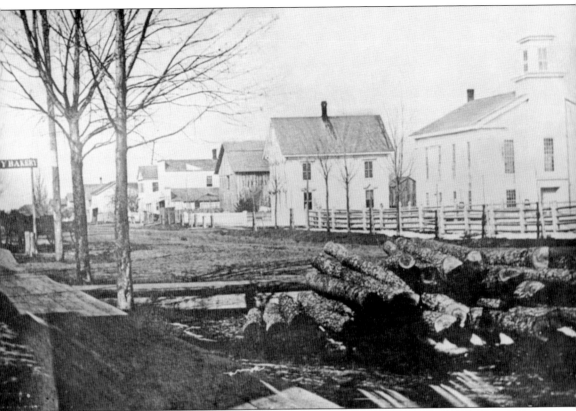

In 1878, this view of Broadway Street looking west from Main Street reveals only a fence on the corner where city hall would later be built. The wooden sidewalks, laid by Henry Wonsey and John Adams, cost $280.95 in 1866. A city ordinance stated that horses were not "allowed to stand, walk, or be driven on these sidewalks."

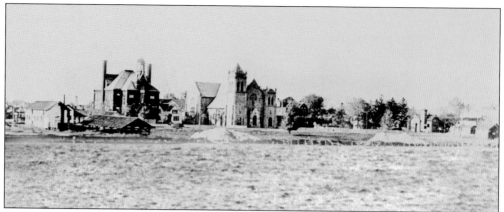

Holy Cross Church on Catholic Point is seen here from the St. Clair River in 1911. The Marine City Stave Company buildings are on the left, and V.A. Saph's residence is on the far right. Saph was a shipbuilder and was the president of the village of Marine in 1866–1867. The first church built in St. Clair County was the Catholic church at Cottrellville, erected in 1826 while Michigan was still a territory. It was washed away when the St. Clair River flooded its banks. Fr. Gabriel Richard donated the land now known as Catholic Point, and a new church was built in 1849. It was replaced in 1903 when Fr. Peter Ternes hired Mathias Sicken of Sicken's Planing Mill and Lumberyard to build a new church for a bid of $33,333.33. By 1874, there were four churches in town: Holy Cross, the Methodist Episcopal, the German Lutheran, and St. Mark's Protestant Episcopal.

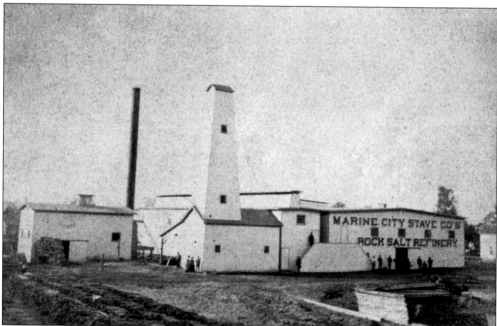

The Marine City Stave Company was incorporated in 1874 by Crocket McElroy, John Batten, William Jones, Hiram Chambers, and Jacob McElroy. That same year, McElroy sunk the town's first salt well on the property located on South Water Street near Bridge Street. Other salt works soon followed suit in the area, as the entire River District sits on top of one of the world's great salt deposits. These included Crystal Flake; Toledo, Davidson and Wonsey; the Michigan Salt Company; Germania; and Roberts and Lester.

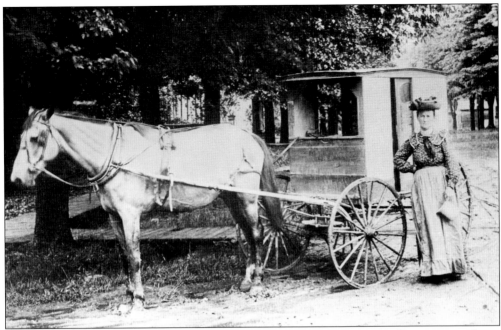

The lady "milkman" of her day was Mrs. Miles McDonald, who delivered milk to town residents. It was transported in five-gallon cans, and McDonald measured it out with a ladle.

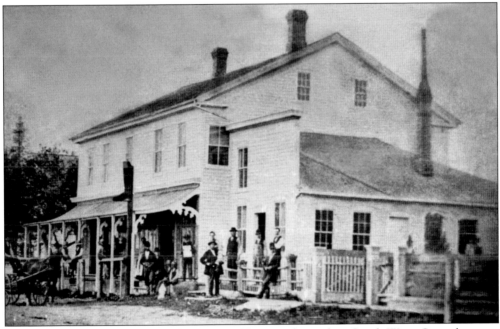

Built in 1834, the John Weng and Son Boot Shop was located on South Water Street between Jefferson and Washington Streets. The boot shop was housed in the small section of the building (on the right), and the Marine City Hotel occupied the larger section. In later times, it was home to Palmer's Bakery and a barbershop.

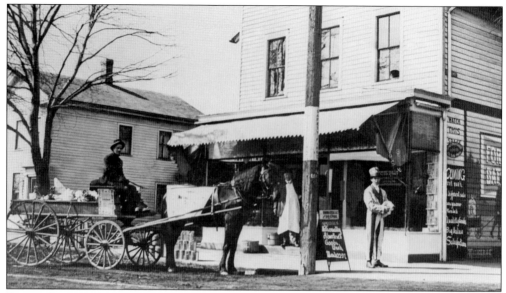

Driving her wagon, Mrs. Brabaw (left) visits William Mannel's Grocery on the southwest corner of Water and Broadway Streets during Nationally Advertised Goods Week in 1915; Mannel (center) is in the apron, and J. Leitch (right) is Uncle Sam. Mannel once sued the Rapid Railway Company for lengthening the curve of its track around the corner and bringing it too close to his store. He also served on the board of directors of the Marine Savings Bank.

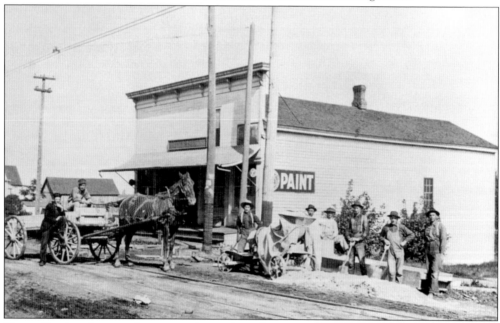

Henry Buttironi's general store was located on the east side of South Water Street between Jefferson and Washington Streets. He inherited the business from his father, a German immigrant, who arrived in Marine City from Detroit in 1854, working as a tailor and eventually building a successful business selling boots, shoes, and general merchandise. Henry was elected treasurer of the village in October 1882. The men in this photograph are installing one of the first cement sidewalks in Marine City.

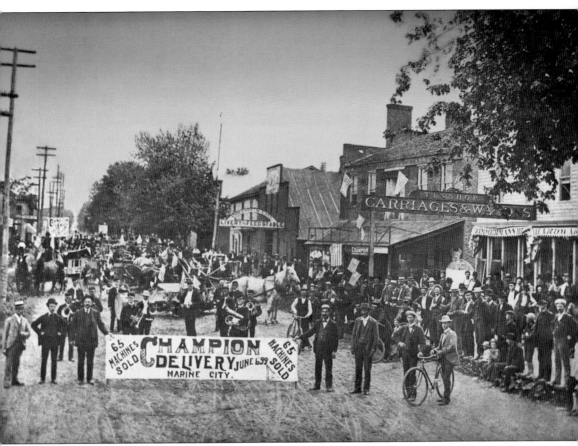

This parade in July 1899 drew a big crowd to watch the Champion Delivery Company celebrate its sales, possibly of farm equipment such as thrashers. Looking south from Broadway Street to Water Street, Zimmermann Brothers Hardware and the Anderson and McCann livery and feed stable are seen on the right. Posing in the foreground are employees of the Champion Delivery Company with their banner proclaiming "65 Machines Sold" in June of that year.

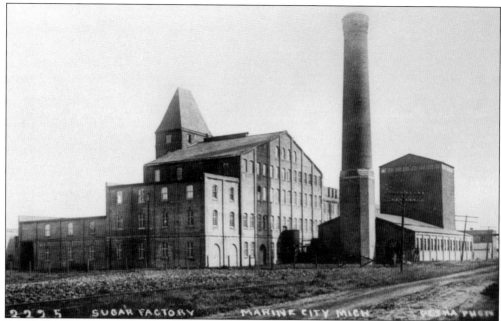

Founded in 1900, the Marine City Sugar Company was located on South Parker Street. It had also been known as the Western Sugar Refining Company and as the Independent Sugar Company by the time it went out of business in 1919. It produced sugar refined from sugar beets and had a 600-ton capacity. The sugar beet was a major cash crop, and the state became one of the foremost producers in the United States, with 16 factories in Michigan. The first president of the sugar company was James Taylor, a retired ship captain who sailed on the *Aztec*, the *Myrtle Ross*, and the *Tempest*. For years, he was also the president and manager of the Crystal Flake Salt Company, as well as president of the Ship Masters Association of Marine City.

South Market Street was commonly called "Barn Street" in earlier years. This moniker came about because of the row of barns lining the street, clearly seen on the left. The photograph was taken looking south from Union Street in December 1900, the end of the season's sugar beet campaign. In the center background stands the original Holy Cross Church, later used as a meeting hall.

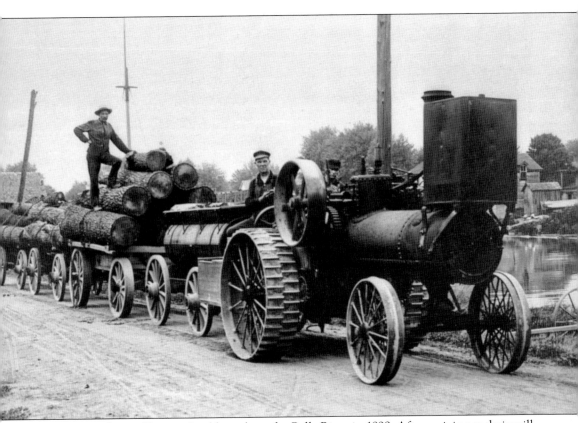

Simon M. Baker and his son haul logs along the Belle River in 1899. After arriving at their mill aboard their Hart-Parr steam tractor, the logs would be made into barrel hoops and staves. In 1860, Baker came to Marine City and engaged in wagon and carriage making. The "S. Baker & Son" mill was established in 1879 at the foot of Washington Street, at first producing doors, blinds, and sash window frames but later converted into a plant to manufacture elm hoops and general saw-milling. The Hart-Parr Gasoline Engine Company is credited with coining the word "tractor," as the machines had previously been called gas traction engines.

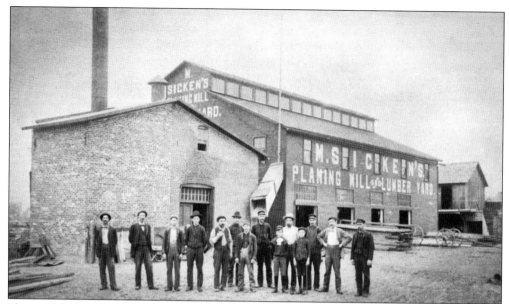

Photographed in the 1920s or 1930s from Bell Street looking northeast, Mathias (or Mathew) Josef Sicken's Lumber and Planing Mill stood at the foot of Elizabeth Street on the Belle River. While their arrangement is lost to history, the members of the crew in this photograph include Andrew Heinkelman, Frank Sicken, Burt Heuser, Nelson Thomas, Hugo Sicken, Nap Liss, Edmund Paquette, James Laffrey, Alex Thomas, Pete Johns, Fred Rivard, Joseph Gaucher, and several unidentified persons.

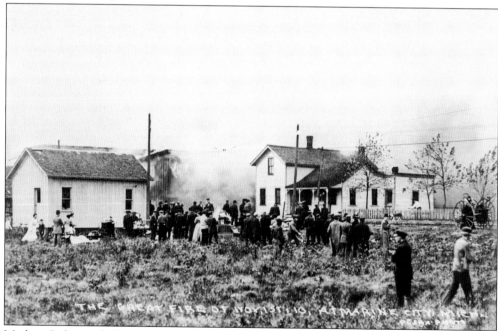

Mathew Sicken's salt block and stave mill were completely destroyed by fire on November 1, 1910; the cause of the fire was never determined. The entire operation was valued at $50,000, a large sum of money for the day. A large, two-wheeled hose reel used for storing and moving the fire hoses to the scene of a fire can be seen on the far right. (Photograph by Louis Pesha.)

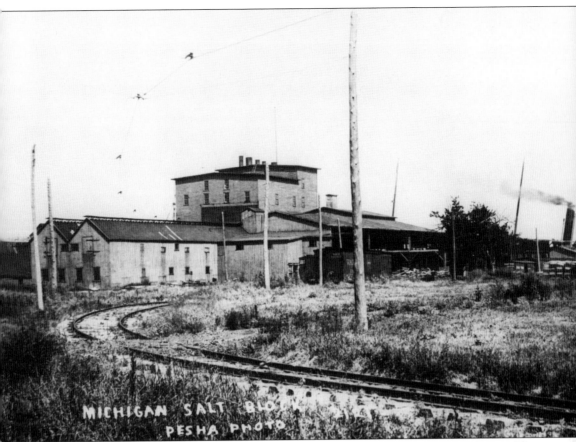

MICHIGAN SALT BLOCK

PESHA PHOTO

Operating just north of Cherry Beach until 1925, the Michigan Salt Block was designed by architect George Mason in 1883. William A. Hazard was president, Edwin J. O'Bryan was vice president, and Sydney McLouth was the secretary-treasurer. According to Charles Cook's 1914 book *The Brine and Salt Deposits of Michigan*, "Steam for evaporating the brine is furnished by five marine boilers. The brine is supplied by two wells, respectively 1,630 and 1,851 feet in depth. The daily capacity is 800 barrels, about 20 percent of the output being turned into table salt. The storage capacity is 60,000 barrels and the number of employees, seventy-five." (Photograph by Louis Pesha.)

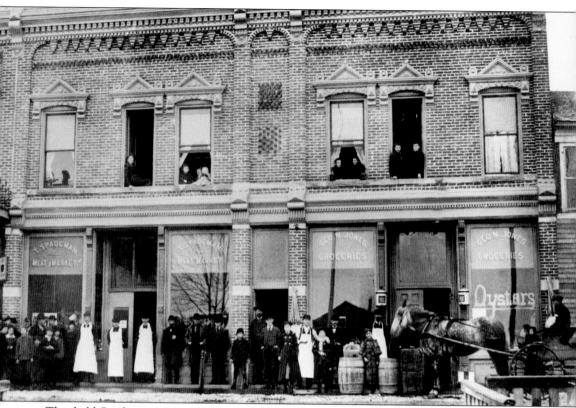

Theobald Spademan's Meat Market and George N. Jones' Groceries were on the west side of Water Street between Washington and St. Clair Streets. Theobald's father, Charles, was born in Germany in 1823, came to Newport in 1850, and worked as a butcher in his own meat market. The market thrived, and in 1873 Charles was the main investor in the schooner *Charles Spademan*. The meat market was later operated by his eldest son, Theobald, who moved it to Water Street in the early 1890s, as pictured here. Theobald is seen standing in the doorway to the market, and Charles is standing with a cane to the right of him. George Jones owned the grocery store next door and was also successful, selling both groceries and ship supplies. In 1901, Jones was the mayor of Marine City and also held office in the Samuel Ward Masonic Lodge No. 62.

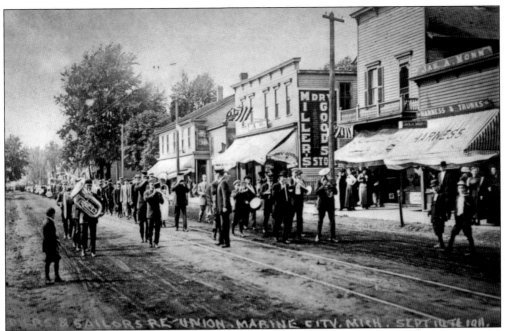

The Civil War drew hundreds of enlistments from St. Clair County. Chartered in 1884, the Grand Army of the Republic (GAR) Harvey Tucker Post No. 229 marches in the Soldiers and Sailors Reunion on September 14, 1911. From left to right, looking south on Water Street, James A. Monn's Harness and Trunks Shop, Miller's Dry Goods Store, and Weng's Boot Shop can be seen in the background. (Photograph by Louis Pesha.)

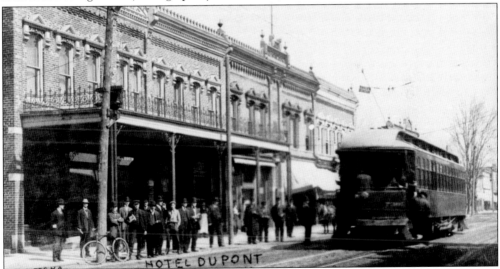

The Hotel Dupont was located on Water Street and served as a Detroit United Railway waiting room. According to the *Thirty-First Annual Report of the Department of Labor of the State of Michigan* published in 1914, the hotel was ordered to "at once put ropes in sleeping rooms for fire escapes to conform with the law; put printed notices in rooms directing the use of ropes; provide individual textile towels in toilet rooms; use sheets ninety inches long on beds." Other hotels in town included the Commercial House on Broadway at Market Street, the Westcott House, and the Colonial Hotel at Union and Water Streets, which offered mineral baths. (Photograph by Louis Pesha.)

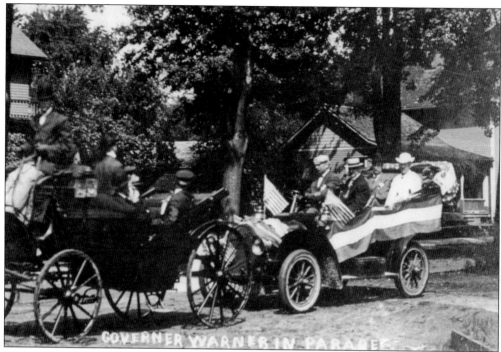

GOVERNER WARNER IN PARADE

Marine City had its share of important visitors for its Labor Day parade, such as Michigan governor Warner. Fred Maltby Warner, a Republican, served as Michigan's 26th governor. From 1901 until 1904, he was secretary of state. In 1904, Warner was elected governor and served three terms (1905–1911). He was known as a progressive who advocated policies such as the regulation of the railroads, child labor laws, and woman's suffrage. (Photograph by Louis Pesha.)

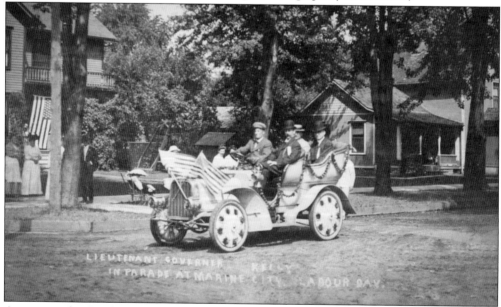

LIEUTENANT GOVERNER KELLY IN PARADE AT MARINE CITY LABOUR DAY.

Arriving in this Stanley Steamer steam car, Lieutenant Governor Kelley also visited for the Labor Day parade. Patrick H. Kelley, a Republican, served as the 33rd lieutenant governor from 1907 to 1911. (Photograph by Louis Pesha.)

26

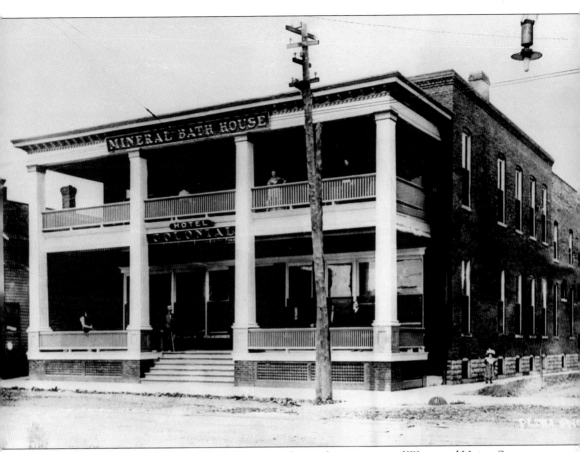

The Colonial Hotel and Mineral Bath House on the southwest corner of Water and Union Streets was built by Dr. Robert Bruce Baird. The minerals were provided by the abundance of brine water from the large salt deposits under Marine City. An 1883 advertisement explained that a major "benefit" of taking a mineral bath was "its promotion of health and comeliness." The Colonial was completely destroyed by fire in 1955. (Photograph by Louis Pesha.)

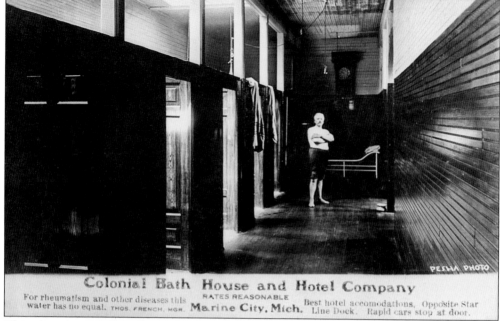

This advertisement shows the interior of the Colonial Bath House and Hotel Company of Marine City, which advertised its mineral water baths as useful for the treatment of "rheumatism and other diseases." (Photograph by Louis Pesha.)

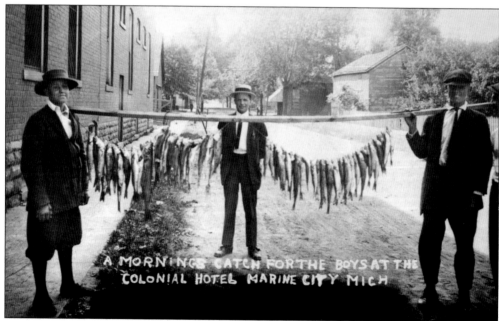

"A Mornings Catch for the Boys at the Colonial Hotel Marine City Mich" was most likely a souvenir postcard. The abundant catch would have surely enticed visitors with another reason besides the mineral baths to visit the area. (Photograph by Louis Pesha.)

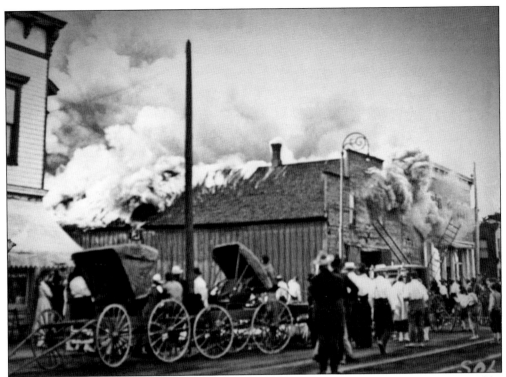

The Anderson and McCann stable and livery on Water Street burned in 1900, as captured by local photographer and pharmacist Sol Foster. Note the line of horseless buggies parked in front of the burning structure.

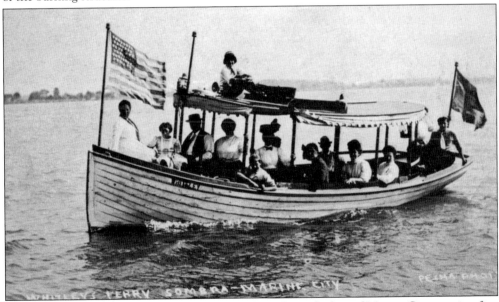

Ferry service across the St. Clair River existed since the early days of Marine City, starting first with sailboats and later by motorized vessels. From the 1880s through the 1930s, Tim Whitely's *Miss America* shuttled people to Sombra, Ontario, and back. To take cars across the river, Whitely towed a barge loaded with automobiles.

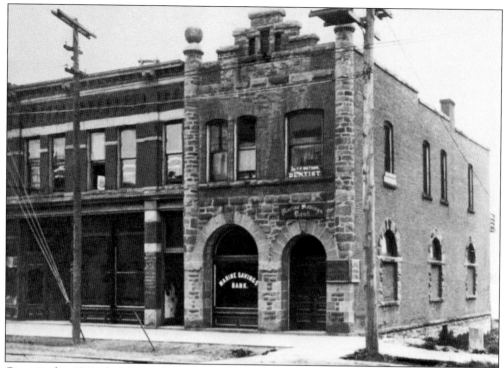

Organized in 1891, the Marine Savings Bank stood on the northeast corner of Water and St. Clair Streets. The bank's entry in the 1907 edition of the *Official Year Book of the Michigan Federation of Labor* read, "This is an up-to-date, but conservative institution, which is run in the interests of the depositors and for the general accommodation of customers. It has a capital stock of $50,000 and a surplus of $25,000. Its directors are men of integrity." The directors of the bank were Mathew Sicken, Robert Folkerts, Frank Hart, C.E. Blood, William H. Mannel, Charles Basney, Sydney C. McLouth, John F. Zimmermann, and Hale P. Saph.

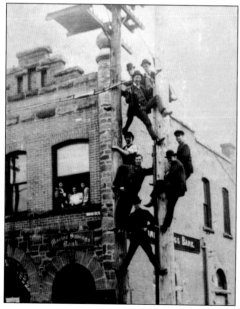

The women in the window worked in the dentist office of Dr. Crevier, directly above the Marine Savings Bank. The way the men on the telephone pole pose is reminiscent of a scene in a Marx Brothers movie. The building was later called the Saph Building.

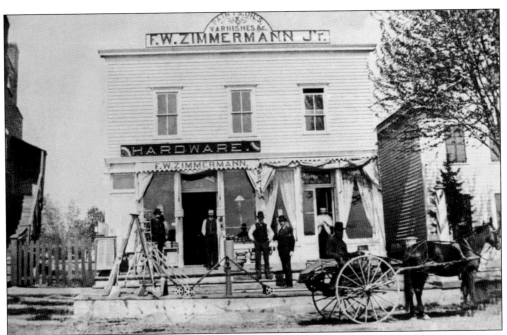

Fred W. Zimmermann Jr. stands in the doorway of his hardware store that he established around 1886 on Broadway Street, just west of Water Street. He sold paint, oil, tools, and general hardware supplies. The little shop just north was Zimmermann's Shaving Parlor. After a very successful period, he expanded the business and organized the firm of Zimmermann Brothers.

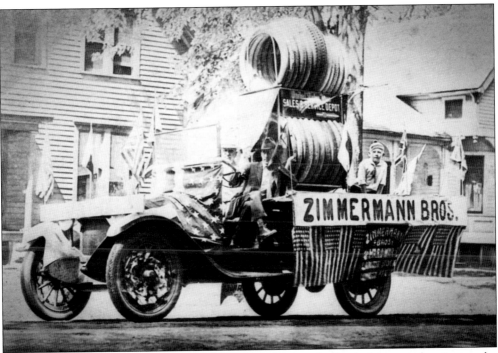

The Zimmermann Brothers Hardware truck is decked out with a load of tires to advertise its sales and service department in the 1919 Labor Day Parade.

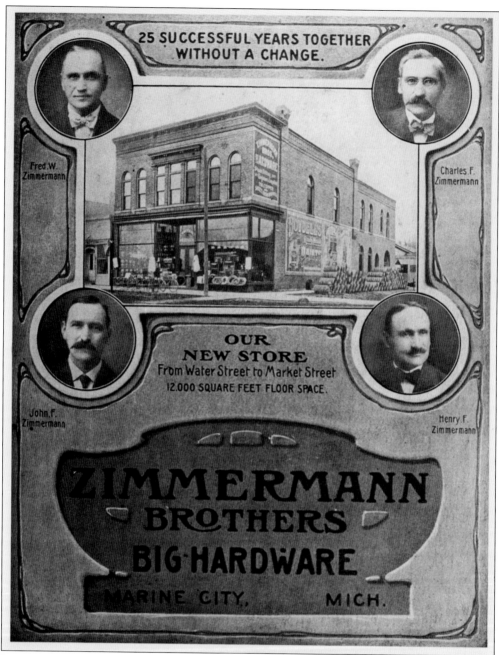

Increasing business demanded a larger storeroom, and in 1900 Zimmermann Brothers Hardware moved from its original space on Broadway to Water Street. The new shop featured a Dodge Brothers Car showroom where carriages were also sold. The 12,000-square-foot property stretched the entire block with its Carriage and Auto Garage on the corner of Market and Jefferson Streets. The business was advertised as "the largest and most up-to-date Hardware and Department Store in southern St. Clair County."

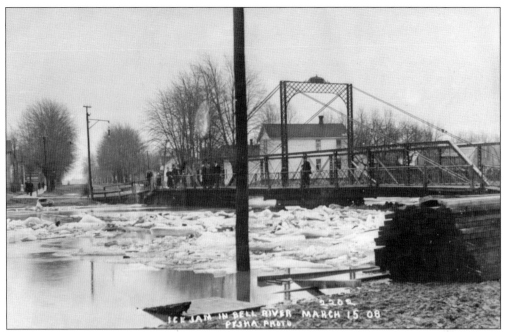

The old Upper Bridge over the Belle River is shown with ice jammed underneath due to a late winter in March 1908. In 1919, it was condemned for heavy trucks; the original bridge accommodated only foot and horse traffic. It was torn down in 1938 or 1939 and replaced with a sturdier structure. (Photograph by Louis Pesha.)

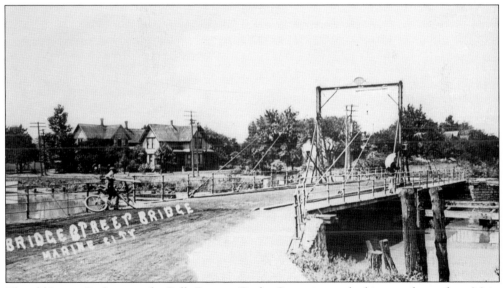

The old Lower Bridge over the Belle River at Bridge Street is seen looking southwest from Main Street. The bridges were commonly referred to as the "Upper" and "Lower." In 1834, a floating bridge was constructed after a line was surveyed from the St. Clair River to the Belle; it was named the Bridge Street Bridge. Long before the bridges were built, folks crossed the Belle River via James Wolverton's or Louis Chartier's ferries.

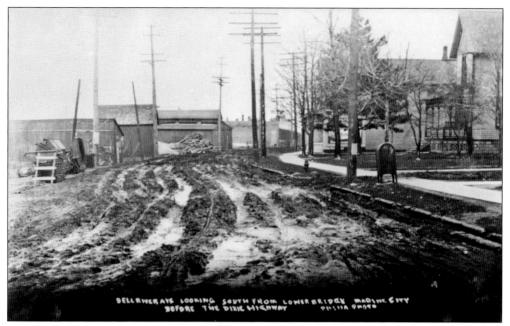

Louis Pesha captured this scene of a muddy spring thaw looking south from the Lower Bridge. His caption reads, "Belle River Ave looking south . . . before the Dixie Highway."

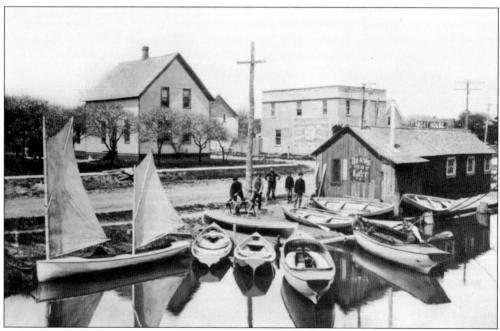

Cottrell's Boat Livery was on the west side of the Belle River at the Upper Bridge. The square building in the center background is W.L. Rivard's Saloon on the corner of Bell Street and Belle River Avenue.

The Bower-Rose Funeral Home on Main Street is captured here in 1924. The house once belonged to local businessman Sydney C. McLouth.

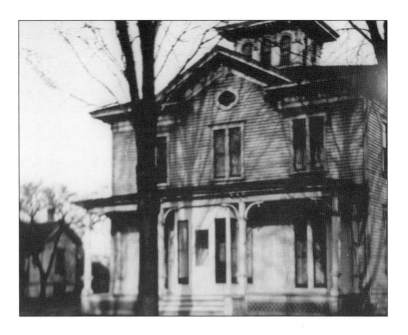

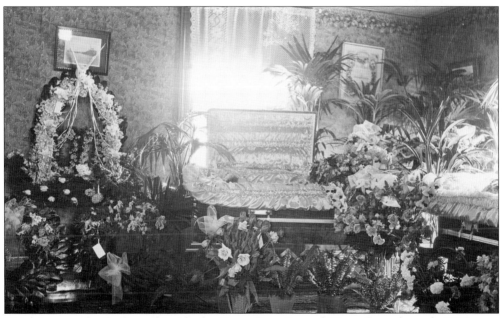

This photograph of a funeral inside the Bower-Rose Funeral Home from the early 1900s may seem odd because the practice is highly unusual in modern times. It was not common for people to have their own cameras or to even have many pictures taken during their lifetime, so post-mortem photographs often were the only image a family had of their departed loved one. Also, another unusual aspect is that this is a double funeral. Because of the expense, funerals were often conducted at home with the service held in the front parlor. Before becoming an undertaker, William Andrew J. Bower was the first mail carrier on the Marine City Rural Route. In 1901, he engaged in the undertaking business and as a sideline sold pianos and picture-framing services. Note the framed picture of a freighter on the wall to the left. (Photograph by Sol Foster.)

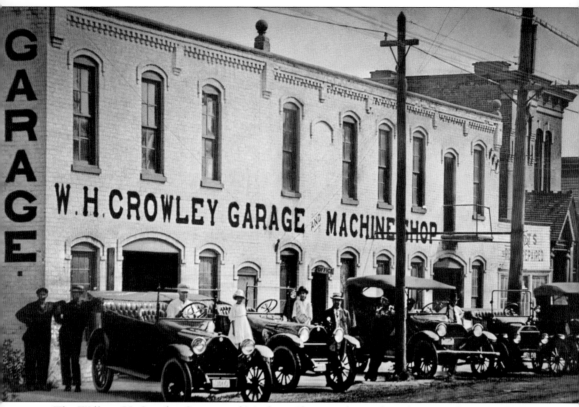

The William H. Crowley Garage and Machine Shop was located on the east side of South Water Street between Broadway and Jefferson Streets. It was formerly the J. Woods and Son Foundry and Iron Works and later became Crowley's Ford dealership. As a young man, Crowley served aboard the *V.H. Ketchum* and the *Pathfinder*. After retiring from sailing, Crowley opened his garage, shown here in the late 1920s or early 1930s.

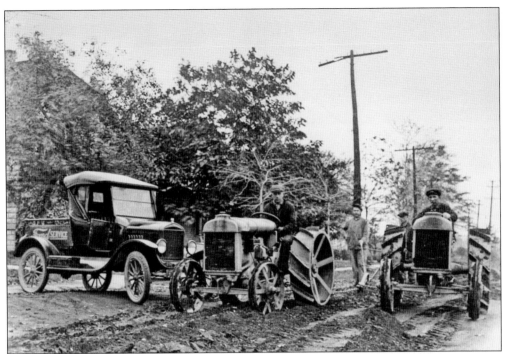

A 1928–1929 Model A open-cab pickup truck from Crowley Ford is shown here with two 1927 McCormick-Deering tractors pulling a plow on Belle River Avenue. International Harvester originally painted all early model McCormick-Deering tractors gray with red wheels. (Photograph by Sol Foster.)

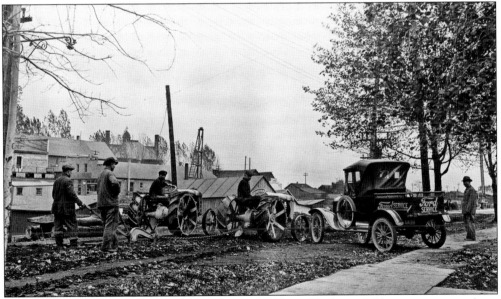

Referring to the Model T in his 1922 autobiography, Henry Ford stated, "Any customer can have a car painted any colour that he wants so long as it is black." He must have caved to consumer demand because he offered the new Model A in three colors: grey, green, and black. (Photograph by Sol Foster.)

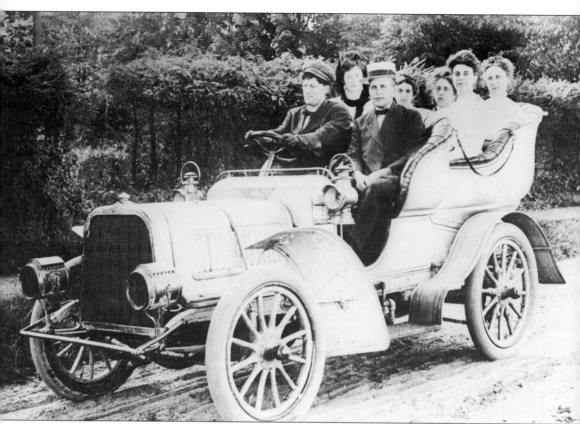

Frank Merrege is out for a drive with friends in his Stanley Steamer steam car; his friend Louis Krapp is in the passenger seat, and the ladies are Elinor Schulte, Ruth Squires, Abigal Kuhn, Teresa Sicken, and Juliette Charbonais. Merrege held a patent for a pneumatic gas and air mixer. Krapp was the proprietor of a dry goods store and sold everything from clothing to carpeting and home furnishings.

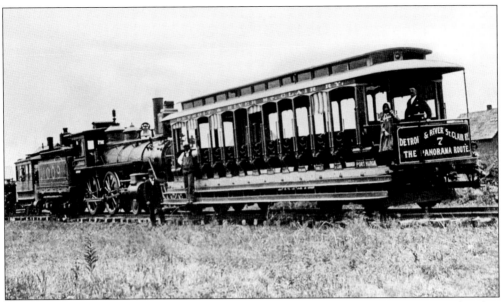

Chartered in 1897, the Detroit and River St. Clair Railroad Company was the first railroad to service Marine City. In 1900, several regional railways, including the Detroit and Port Huron Shore Line Railway and its subsidiary the Rapid Railway Company, were consolidated as the Detroit United Railway (DUR), which operated an interurban electric railway. The DUR operated 50 electric motor cars on just over 379 miles, with 123 of those between Detroit, Mt. Clemens, New Baltimore, Algonac, Marine City, St. Clair, and Port Huron.

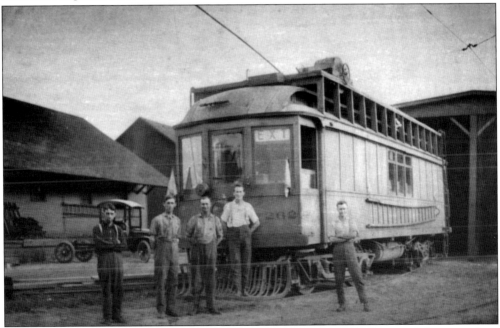

The DUR interurban work car No. 7262 is shown in 1916 at the trolley barn with her crew, from left to right, Joseph Cremean, Bert May, Gus Buchler, Ted Nelson, and Lloyd Napper. May was an electrician. The ladder, visible on the right, hung on the side of the car and was clearly never used or flipped over, hence its curve.

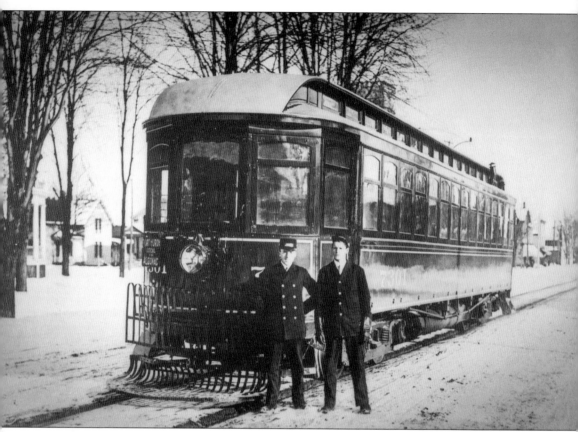

Headed west on the south side of city hall, DUR car No. 7301 is stopped in front of the town gazebo, visible to the left. Among the men from Marine City employed by the DUR were motormen and conductors Crandell, Poulliot, Fagan, and McDonald. "The Road of Good Service" offered very fast transportation to Detroit or Port Huron, with service every hour.

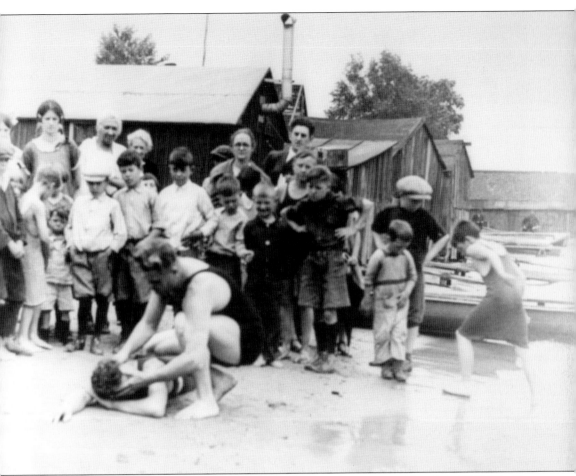

Lifeguard Guy Taylor gives a life-saving demonstration at the swimming beach in 1925. The St. Clair River was important for many facets of life beyond commerce and industry; it played a role in recreation, providing an outlet for swimming, fishing, and boating. Taylor was the son of Capt. James Taylor. Later in life, he would become the son-in-law of Sydney McLouth, the captain of the steamers *John Owen* and the *Peirce McLouth*, fleet captain for the McLouth ship fleet, and mayor of Marine City.

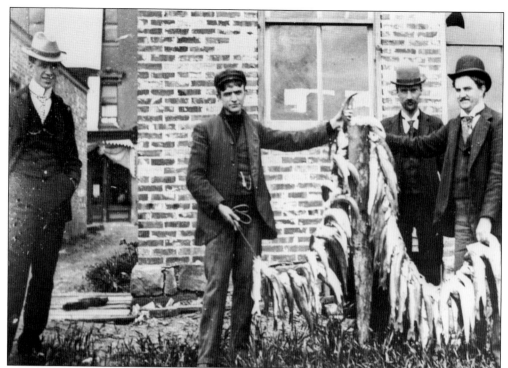

Behind Crowley's garage, these men show off two stringers full of fish taken from the St. Clair River.

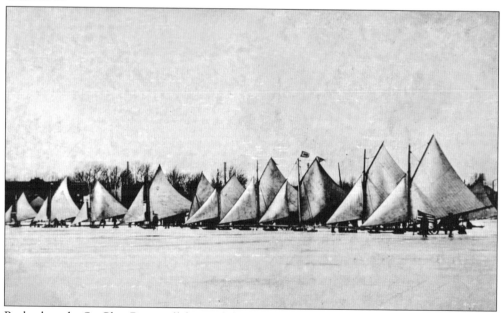

Back when the St. Clair River still froze solid, "ice boating" or "ice yachting" was a very popular form of winter recreation. These vessels flew large sails to catch the wind and ran on skates that were several feet long. Piloted by a skilled "yachtsman," they were known to reach speeds as fast as 65 miles an hour. They were even used during Prohibition by rumrunners to outrun and outmaneuver the police and the border patrol. (Photograph by Louis Pesha.)

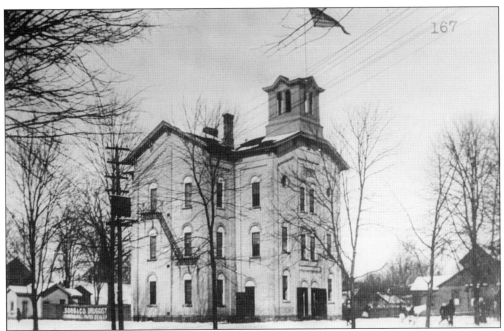

The Union School was located on the northwest corner of Washington and Main Streets. It was built in 1870 of white brick in the shape of a Greek Cross and burned almost three decades later in 1899. The school was built for $15,000 and was designed by Benjamin S. Horton. Stephen Mittig of St. Clair completed the mason work, and the joiner work was done by George Laugell of Marine City. George R. Whitmore served as the school's first principal.

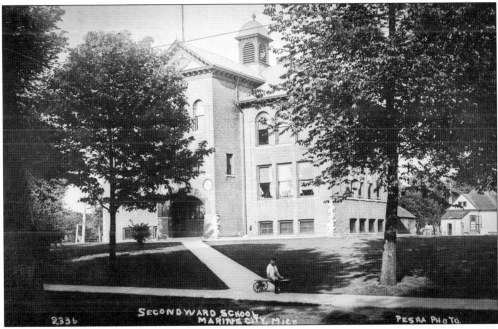

The Second Ward School was built in 1894 on North Mary Street. It was torn down in 1965. (Photograph by Louis Pesha.)

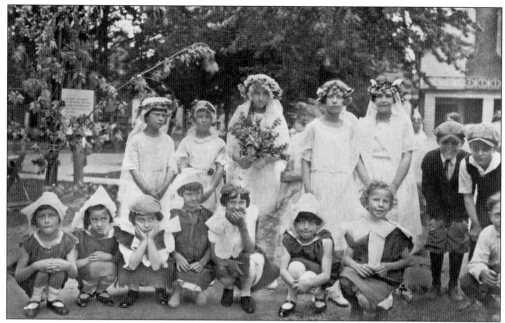

These students of the Second Ward School enjoy a day outside of the classroom dressed for an end-of-year pageant in the early 1920s. The end of the school year was an exciting time for kids then, as they looked toward their summertime fun: swimming and fishing in the St. Clair and Belle Rivers, playing kick the can or tag, jumping rope, shooting a game of marbles, or playing a sandlot game of baseball. Popular children's toys of the time included Lincoln Logs™, invented in 1916 by John Lloyd Wright, the son of famous American architect Frank Lloyd Wright; the Erector Set™, Tinkertoys™, Raggedy Ann™ dolls, marbles, jacks, and 5¢ eight-crayon boxes of Crayolas™ and coloring books. (Photograph by Sol Foster.)

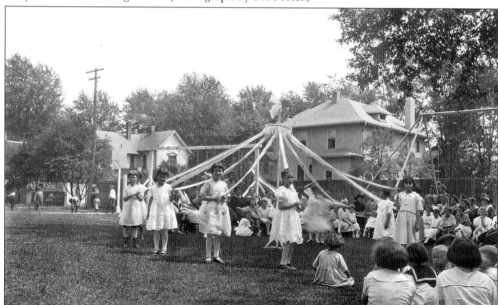

These girls pose for their picture before dancing around the May Pole. (Photograph by Sol Foster.)

Elizabeth Street, seen around 1900, was an example of the typical Marine City neighborhood with large, stately homes on tree-lined dirt streets. (Photograph by Louis Pesha.)

Capt. Arthur Burrows's home stood on the corner of Market and Washington Streets. (Photograph by Louis Pesha.)

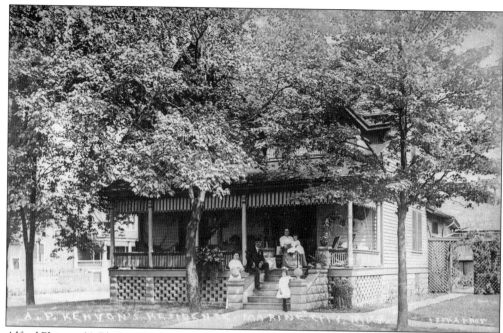

Alfred Phineas (A.P.) Kenyon's house stood on the corner of Market and Bridge Streets. (Photograph by Louis Pesha.)

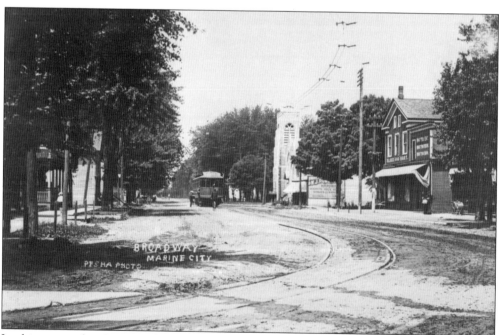

Looking west, the electric railway tracks curve around from Water Street to Broadway. To the right are Blood and Hart's store and a DUR car in front of the United Methodist Church in the center background. (Photograph by Louis Pesha.)

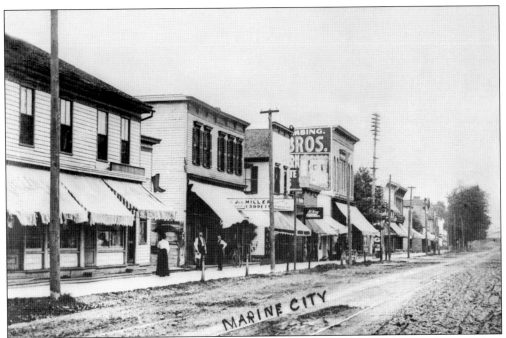

John Weng (center) and Joseph Miller (right) are pictured in 1901 standing in front of their businesses on the west side of Water Street looking north from Washington Street. Miller ran a haberdashery shop. (Photograph by Louis Pesha.)

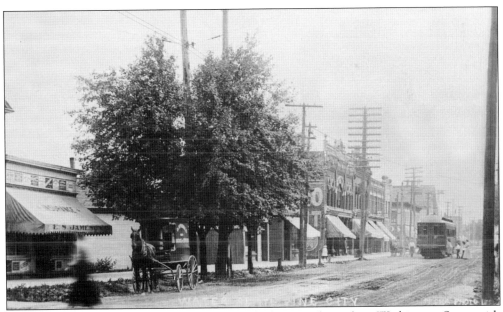

This photograph from 1900 shows Water Street looking southeast from Washington Street with the DUR car to the far right heading north. Note the multiple cross arms on the telephone poles, as each phone had to have its own line in to the operator's switchboard. (Photograph by Louis Pesha.)

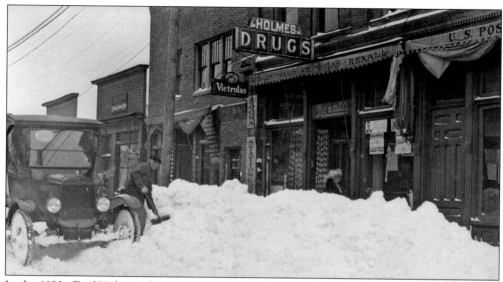

In the 1920s, Fred Holmes's drugstore was next to the post office on the east side of Water Street. Holmes employed Sol Foster, a local photographer, as a druggist. Foster would go on to a pharmacy in town, Foster Drugs. Besides being a Rexall pharmacy, Holmes was also a Victrola phonograph dealer. The Victor Talking Machine Company manufactured Victrolas from 1901 through 1929. (Photograph by Sol Foster.)

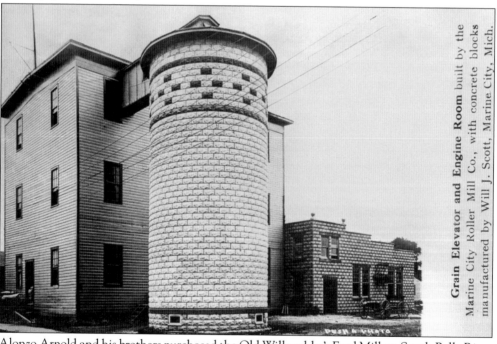

Grain Elevator and Engine Room built by the Marine City Roller Mill Co., with concrete blocks manufactured by Will J. Scott, Marine City, Mich.

Alonzo Arnold and his brothers purchased the Old Willoughby's Feed Mill on South Belle River Avenue between Delina and St. Clair Streets, later known as the Marine City Roller Mill Company, in 1874. They produced Perfection and Our Best flour. In 1894, Marine City's first electricity was created here to run Heisler Electric Light Company incandescent lighting apparatus and also to sell to the local citizenry. The Arnold family later sold out to the Eastern Michigan Edison Company. (Photograph by Louis Pesha.)

Erected in 1883–1884, the waterworks was located on the St. Clair River on the east side of North Main Street between Holland and Westminster Streets. Morley and Bower of Marine City built the waterworks as well as city hall. The building was demolished around 1940. Andrew Bower was the son of William Andrew J. Bower of the Bower-Rose Funeral Home. This photograph was taken from the river's edge, looking westward.

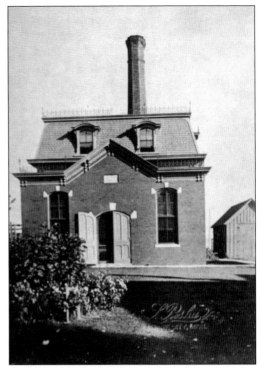

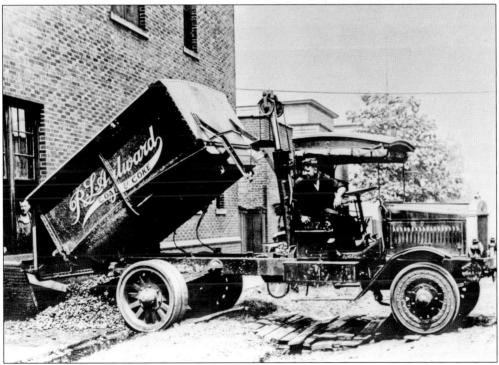

The waterworks was operated by coal fire and powered by steam. This R.L. Aylward Coal and Coke delivery truck is shown making a delivery to the waterworks. Richard Aylward was a retail coal merchant from Detroit.

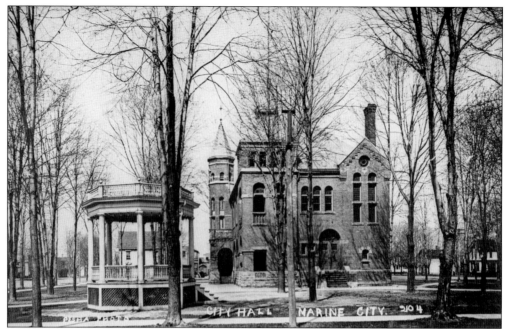

City hall, constructed in the area of town known as "The Park," is shown here looking west from Main Street just north of Broadway. Frank McElroy headed the effort to build it in 1883, and George DeWitt Mason and Zachariah Rice designed it in the same year. It was completed in 1884 for a cost of $12,310.34 by Morley and Bower. (Photograph by Louis Pesha.)

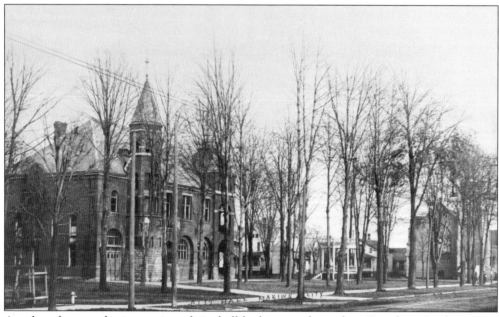

Another photograph gives a view of city hall looking northeast from Broadway. Its design was influenced by the shingle and Romanesque revival style of Henry Hobson Richardson, who famously designed Trinity Church in Boston. Mason would go on to design the Grand Hotel on Mackinac Island, the Detroit Opera House, the Belle Isle Aquarium, the Detroit Masonic Temple, and the Detroit Yacht Club. (Photograph by Louis Pesha.)

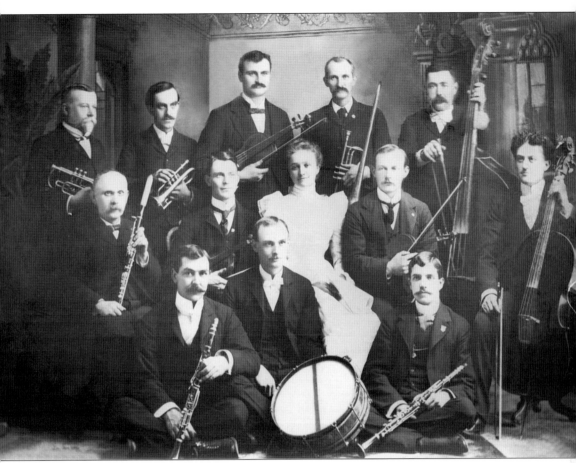

Marine City's Concert Orchestra, pictured here in 1895, performed in the Marine City Opera House at city hall. The ensemble members are, from left to right, (first row) ? Woods (clarinet), Daniel Utley (drum), and Frank Laden (clarinet); (second row) John Herman (clarinet), Albert McNiff (violin), Alvina Springborn Berner (piano), Frank Kliemann (violin), and Frank Merrege (cello); (third row) G.A. Carmen (cornet), Eber Arnold (cornet), Henry Wood (violin), Herb Lester (trombone), and William Wellhausen (bass violin).

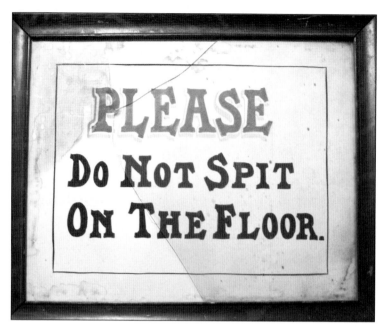

This sign came from the Marine City Opera House, a venue that often hosted boxing matches and other events that drew big crowds of onlookers. Tobacco chewing was common among the farmers, sailors, factory men, and other men of the age who attended these entertainments, so this served as a polite reminder to aim for the spittoon, not the floor.

The Marine City Opera House on the second floor of city hall offered town residents regular entertainment and social events such as concerts, balls, plays, and Vaudeville shows like this travelling minstrel show. Dances were held in the winter months when the sailors were home for the season, and it also hosted a popular speaking series called the Chautauqua, which traveled circuits throughout small towns and rural America from the early 1900s until the mid-1920s. The Chautauqua, originally established in New York State, brought culture, entertainment, and education to the entire community, with entertainers, speakers, teachers, musicians, preachers, and experts of the day.

The Ship Masters Association held its annual ball at the Marine City Opera House in city hall. Although this invitation does not specifically state that it is for the event, there is a good chance that it indeed was, as it is dated for the time of year when captains and sailors would be home for the winter.

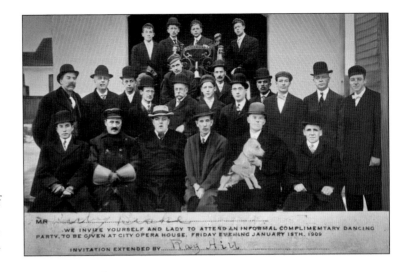

MR _____
____WE INVITE YOURSELF AND LADY TO ATTEND AN INFORMAL COMPLIMEMTARY DANCING PARTY, TO BE GIVEN AT CITY OPERA HOUSE, FRIDAY EVENING JANUARY 15TH, 1909

INVITATION EXTENDED BY____Ray Hill____

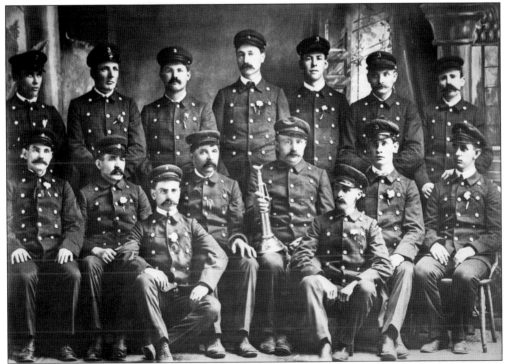

The Marine City Fire Department poses for this photograph in the early 1900s. The chief sits in the center with the brass speaking tube, an early type of bullhorn. The department was housed in the west side of city hall. Its canvas hoses were hung to dry from a rack built into the southwest tower. The fire department's predecessors were the all-volunteer Star Hook and Ladder Company whose members included Hale Saph, who would later be the president of the Marine Savings Bank, and George Anderson, who was once Henry Ford's personal secretary. Going even further back in the town's firefighting history was the Niagara Hose Company No. 2, which housed its equipment at the building that was once the Newport Academy.

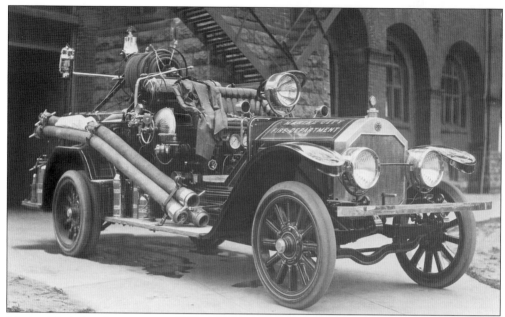

Marine City's first fire engine, a 1923 or 1924 American La France Type 75, sits in front of city hall. By the 1920s, firefighting techniques and equipment had evolved drastically since the days of all-volunteer fire brigades using hand-pumped water tanks or steam engines drawn by horses. They now had the advantage of the combustible-gas engine in motorized fire engines and ever-expanding networks of water pipes and fire hydrants. They were also expected to participate in formal training by climbing ladders, practicing rescue techniques, and learning how to properly use and care for hoses and firefighting equipment. (Photograph by Sol Foster.)

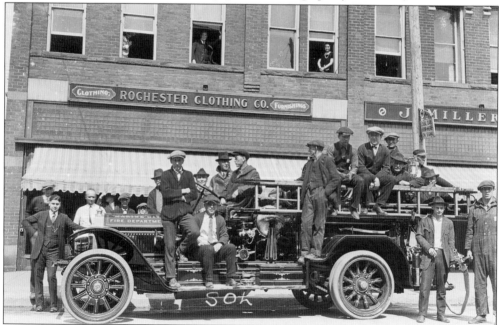

Seeing these men on and around the LaFrance engine as seen on Water Street allows a perspective of its actual size as compared to the previous image. (Photograph by Sol Foster.)

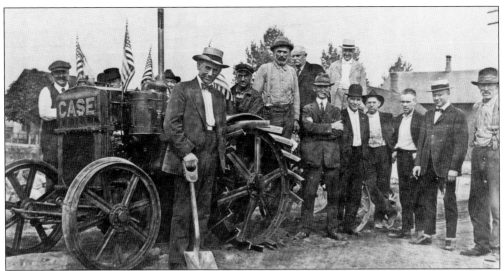

Holding a shovel, Mayor Dr. Thomas E. DeGurse poses with the crew working on Marine City's first street-paving project in 1921. From left to right are James Worswick, Louis Carfrae, Charles Doyal, Thomas DeGurse, Joseph Britz, Eugene Pozey, Grafton MacDonald, Fred Becker, John Breining, Joseph Rose, Earl Avers, John Carmen, and John Yeip. Elected for several terms, DeGurse was a popular mayor with the citizens of Marine City. During his 50 years of service to the community as a doctor and a politician, his persistent efforts resulted in many improvements to the city, including the erection of the waterworks and the city filtration plant.

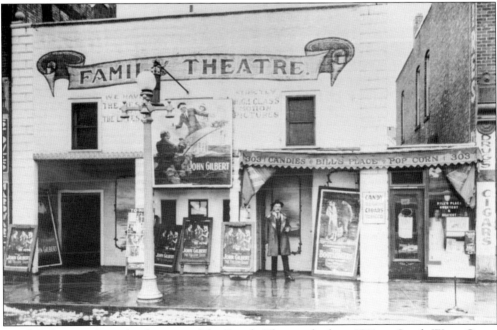

Frank Baker stands in the doorway of the Family Theatre, built in 1911, at South Water Street between Washington and St. Clair Streets. On the marquee is John Gilbert starring in 1922's *The Yellow Stain*. Next to the theatre was a popular hangout for kids in the Roaring Twenties, Bill Cattanach's candy shop. He advertised, "The neatest and sweetest, also the Biggest Little Store in this city," selling confections, ice cream, soft drinks, popcorn, peanuts, and cigars and tobacco.

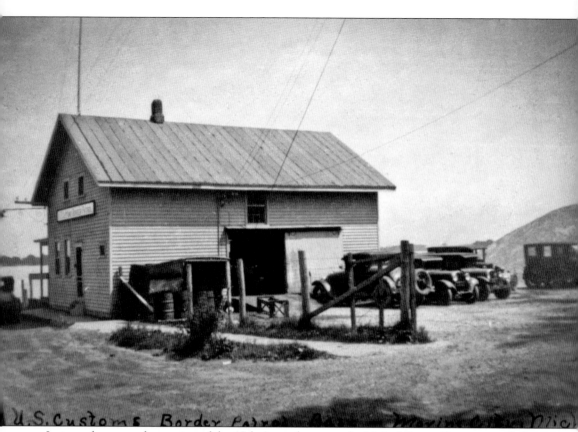

U.S. Customs Border Patrol

In its early stages, the passing of the 18th Amendment to the United States Constitution led to a general decrease in alcohol consumption and fewer alcohol-related arrests. Much to the delight of temperance movement supporters and progressive reformers, it seemed at first that America's "great social and economic experiment" would be a success. It was not long, however, before the federal government realized that enforcing the Volstead Act would prove to be a challenge, as the illegal production and sale of alcohol was running rampant. The Prohibition era turned the US/Canada border into a hotbed of criminal activity. Pictured here in 1929, the US Customs and Border Patrol Office undoubtedly saw its fair share of action while defending the experiment that was, as Herbert Hoover stated, "Noble in motive and far reaching in purpose." It also served as the waiting room for the passenger steamer *Tashmoo* and other excursion steamers.

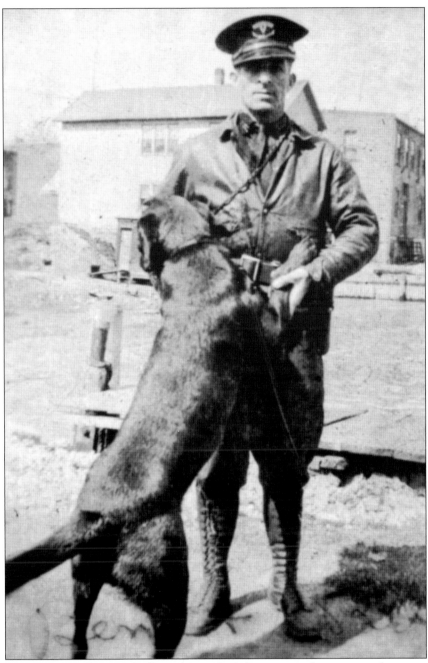

Working as a US Border Patrol officer during Prohibition must have required a great deal of integrity and fortitude, as it was quite common for bootleggers and speakeasy owners to bribe local law enforcement. The wild days of rum-running fostered a great deal of corruption as well as a general disrespect for the law and its enforcement. The temptations Watchman Stewart and his dog Ben may have encountered while on patrol duty must have been great since the average officer only made $30 to $40 a week, whereas a bootlegger could make thousands of dollars in a month. This 1929 photograph, showing Stewart's erect posture and set jawline, seems to offer us console that he was filled with an honest character and pride for his work.

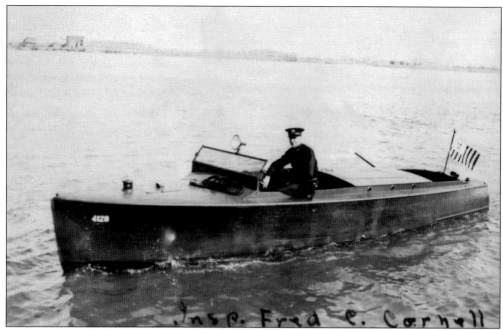

The need for secure borders came with the passing of the Immigration Acts of 1921 and 1924. With limitations placed on the number of immigrants allowed into the country each year, the US Border Patrol was established by an act of congress in May 1924 in the hopes of minimizing illegal entry. The services of the US Border Patrol became a valuable resource to the Bureau of Prohibition, organized in 1927, as it contributed to the enforcement activities along the US and Canada border. Inspector Fred C. Cornell, shown sitting in a Chris-Craft motorboat off the shore of Marine City in 1929, and numbers of inspectors like him had the advantage of using speedboats to patrol the miles of shoreline they monitored while on duty.

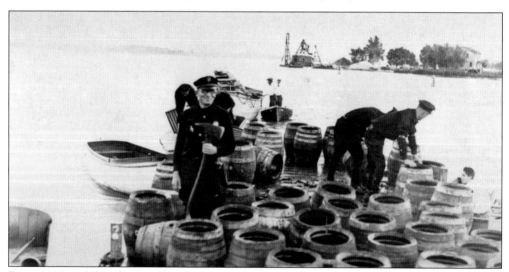

From 1920 to 1933, the St. Clair River, an ideal smuggling route, along with its neighboring waterways, transported 75 percent of the United States' black market liquor supply from Canada. Federal officers often destroyed their illegal finds immediately, as this image taken on a barge in the St. Clair River shows them busily busting open barrels of beer.

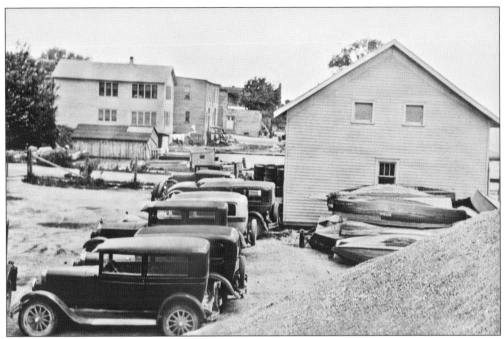

The US Border Patrol Headquarters is shown here in 1929, with its patrol cars, customs house, and confiscated rumrunner boats. The common idea that big crime figures—Al Capone, the Purple Gang, the Westside Mob—were the sole contributors to Prohibition law-breaking is misleading. The fact is, the folks next door were largely responsible for the proliferation of alcohol through the black market.

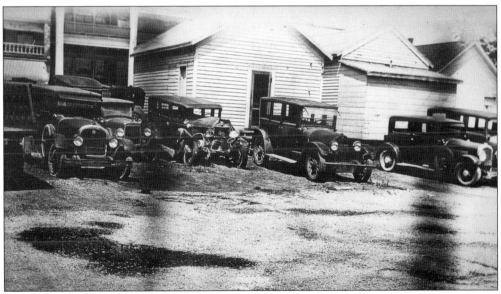

Cunning, skill, and inventiveness were the name of the game for Prohibition-era rumrunners. Underground tunnels, hidden cargos, and double "gas tanks" in automobiles all offered resourceful ways to smuggle alcohol from Canada into the United States. Confiscated cars were repurposed by the border patrol for use as patrol cars. Looking through the fence at the impound yard of the U.S. Border Patrol, this picture shows a sizeable collection of seized automobiles.

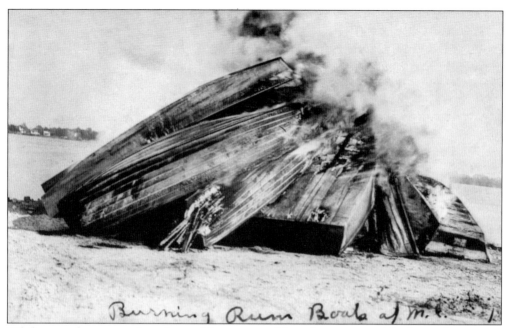

Burning Rum Boats at M. I.

While a good amount of confiscated items were able to be repurposed by law enforcement, the US Border Patrol set these boats ablaze so that they would never fall back into the hands of rumrunners.

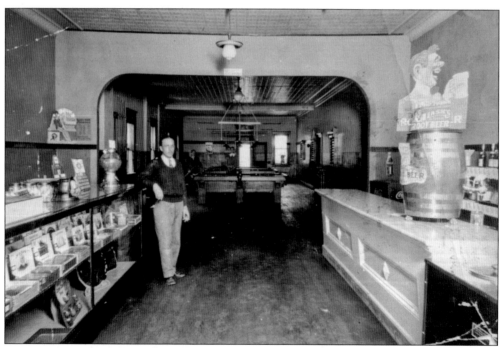

Frank Beauvais's Bar, located on South Water Street, offered root beer, cigars, and pool in the back. Beauvais is pictured at the front of the bar in 1931. His working-class attire and the wholesome advertisement for Lash's Old Fashioned Root Beer seem to be markedly removed from the times described in F. Scott Fitzgerald's iconic depiction of the Roaring Twenties in *The Great Gatsby*.

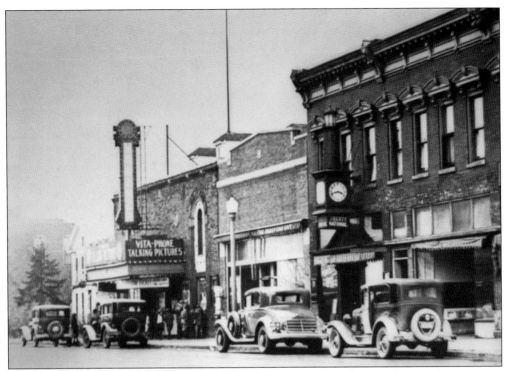

The Mariner Theater was on South Water Street, as seen in this photograph sometime between 1927 and 1930. Admission to the Mariner cost 10¢, and it showed the news, a short comedy or a cartoon, and the main feature. Sunday matinees drew the largest crowds, with the line sometimes stretching down the block. Projector breakdowns were not uncommon and were usually accompanied with the typical boos. Note the Vita-Phone Talking Pictures sign on the marquee. Bell Telephone Laboratories and Western Electric collaborated to develop the Vitaphone system, which synchronized 12-inch, 33 1/3-rpm audio records to film; it was used in the first talkie, *The Jazz Singer*, starring Al Jolson.

On May 16, 1936, Mayor Thomas DeGurse (right) and chief of police William Williams pose beside Marine City's first police car, a 1936 Ford Fordor sedan, which had a 221-cubic-inch, 85-horsepower, flathead V-8 engine.

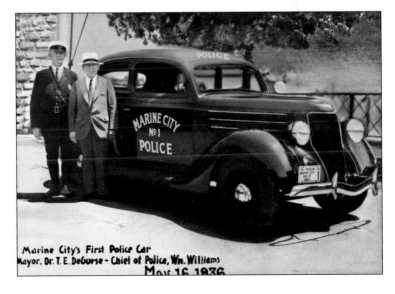

Marine City's First Police Car
Mayor. Dr. T. E. DeGurse - Chief of Police, Wm. Williams
May 16 1936

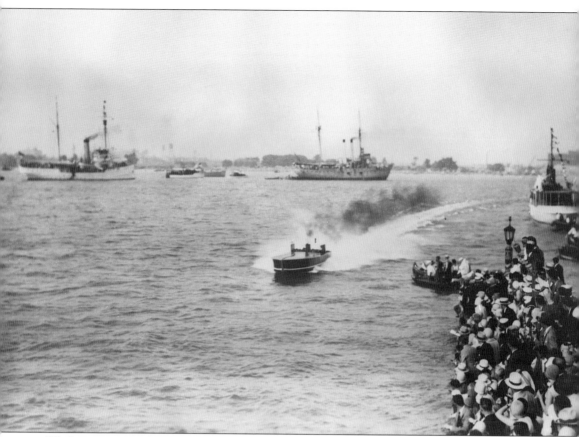

While spectators gather in boats and ashore, Garfield "Gar" Arthur Wood and his mechanic, Orlin Johnson, race *Miss America X* in the Harmsworth Trophy Race held in Marine City in September 1933. They won the race against Englishman Hubert Scott-Paine's *Miss Britain III. Miss America* had four powerful 12-cylinder Packard engines, plus a supercharger that produced 6,800 horsepower. She won the 1932 and 1933 Harmsworth race and set a long-standing world record of 124 miles per hour in a timed straightaway. Between 1920 and 1933, Wood won the Harmsworth race eight times as a driver and nine times as an owner. Besides being famous for being the world's fastest boat racer, Wood was a wealthy industrialist who made his fortune by inventing the hydraulic dump-truck lift. He became the first man to go 100 miles an hour on water and the first to do two miles a minute in a boat. *Miss America X* was designed by Napoleon "Nap" Lisee. Lisee is credited with designing more than 30 of the world's finest race boats, including all 10 *Miss Americas*, all of the *Miss Detroits*, and all of the *Baby Gars, Baby Americas,* and *Gar Jr.* boats.

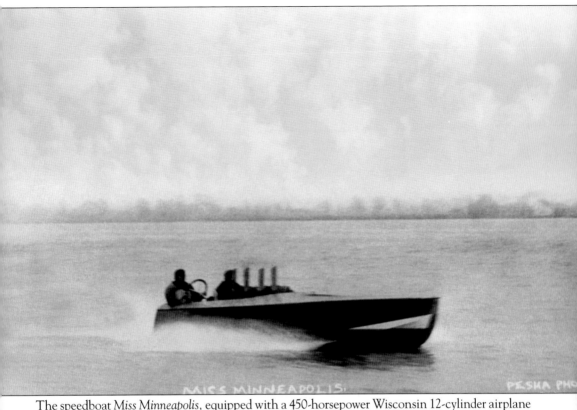

The speedboat *Miss Minneapolis*, equipped with a 450-horsepower Wisconsin 12-cylinder airplane engine, is seen zooming down the St. Clair River at Marine City. The *Miss Minneapolis* was designed by Gar Wood's one-time boat builder Christopher Smith, and in 1916 she was the first boat to ever break the 60-mile-per-hour speed barrier. After working with Wood for six years, Smith founded Chris-Craft Boats and became famous for building mahogany-hulled powerboats at his factory in nearby Algonac, Michigan, in 1922. The company adapted and perfected the assembly line technique to boat building, which drove costs down and made pleasure boating affordable for the general public for the first time. Building through the 1950s, and still a household name, Christopher Smith is to the powerboat industry what Henry Ford is to the automobile industry.

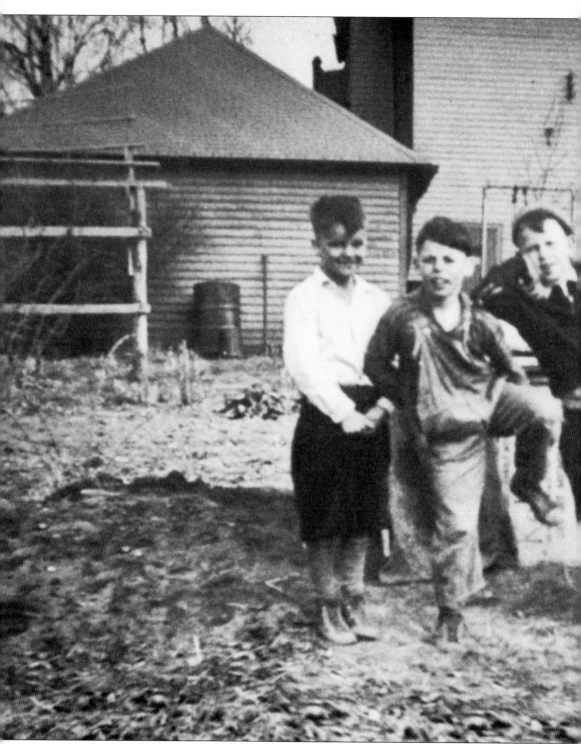

This neighborhood crew looks like it came straight out of an "Our Gang" movie short. Standing from left to right are Robert "Bob" Spicer, Lowell Stager, Lawrence Taylor, Walter Smith, and Nelson "Jack" DeLisle (in a pilot's helmet). The picture was taken in the 1930s in the vacant lot

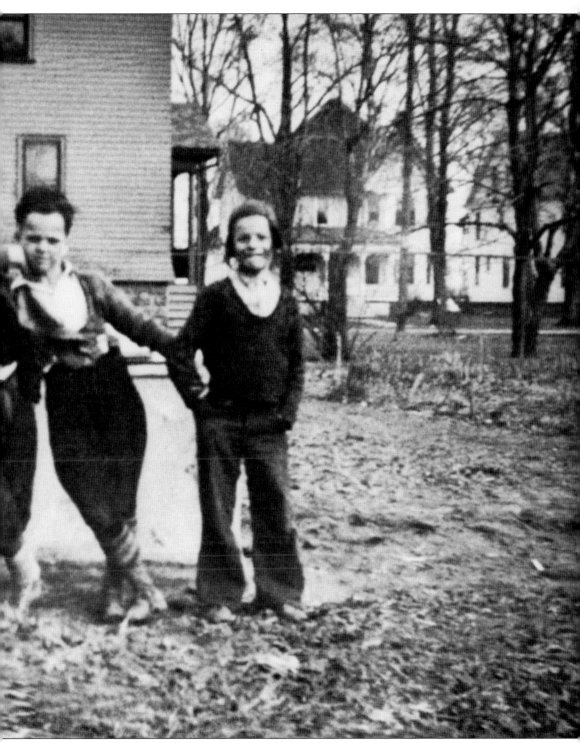

on the north side of the DeLisle home on North Elizabeth Street. The house in the near center background was Capt. James Taylor's, and the house in the far background was Capt. Hugh Ragen's on Main Street.

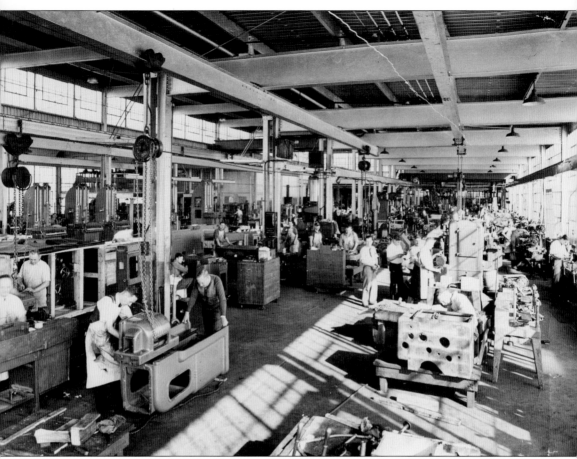

Ground-breaking for the Detroit Gasket and Manufacturing plant was on July 24, 1939. It was located on Ward Street, just west of the railroad tracks. Through the years, the plant employed many townspeople to produce a wide range of automotive products, including gaskets, trunk liners, glove boxes, and grilles and moldings.

Two

A Maritime Town
Shipbuilders and Sailors

Well before the advent of steel-hulled ships, Marine City established its identity as a shipbuilding community. Hundreds of skilled laborers lived here and worked in the yards. Like true craftsmen, they intimately knew every inch of a ship, skillfully building the hulls, the cabins, and the yawls and even right down to the steering wheels. By 1885, the Belle River was home to five shipyards that produced the finest ships on the lakes. In 1886 alone, a dozen ships were launched. Launch days always drew big crowds; water, mud, and fish often washed up on the opposite shore as the boats were pushed into the Belle River, causing cheerful onlookers to gleefully scramble for safety.

Shipyards were owned by men with names such as Kenyon, Anderson, Lester, and McLouth. In the 30 years between 1846 and 1875, not a single year passed without at least one boat being constructed. The Lester shipyard alone built 62 boats between 1857 and 1899. The 260-foot propeller *V. H. Ketchum*, the largest ship on the Great Lakes at the time, was built at Lester's yard in 1874. The *Ketchum* was topped by Morley and Hill's *Italia* in 1889, an even larger steamer at 289 feet. The last boat constructed in Marine City was the *Wit*, built in 1932 by Peirce McLouth.

Marine City also supplied its share of ship captains and sailors to serve aboard the boats built here. The 1890 annual review edition of the *Marine City Magnet* claimed that there were 350 men in the area earning their living on the lakes. As they sailed past the town, boats would blow unique signals, beckoning sailors' wives and families to the riverbank to call to their husbands and fathers. Because of this tradition, Marine City earned the nickname "Yoo Hoo Point."

Shipbuilding and sailing, it was clear, was not only an industry, but also a way of life.

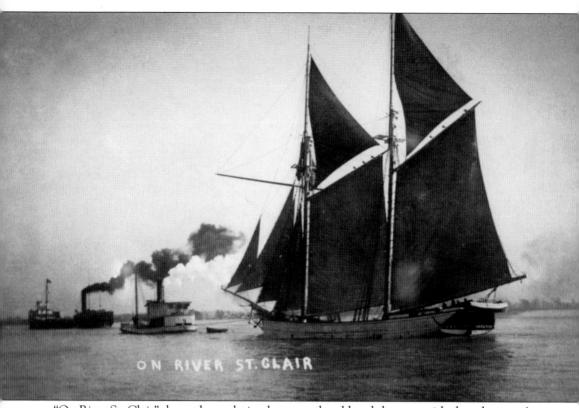

ON RIVER ST. CLAIR

"On River St. Clair" shows the evolution between the old and the new, with the schooner *Azov* under tow on the St. Clair River. This image serves as a nice example of the changing times, documenting the transition to steam-powered and motorized vessels from the sailing ships that dominated the 1800s. (Photograph by Louis Pesha.)

Samuel Ward, the founder of Newport, was born in Vermont in 1784 and died in Marine City in 1854. Ward built the *St. Clair*, the *Sam Ward*, and the *Huron*. According to *A History of St. Clair County, Michigan* by A.T. Andreas, "The manner in which Capt. Ward paid his carpenters would be a novelty now. The wages averaged about $1.50 per day, payable half in goods and half in cash in six months. If a man took flour or pork, it was cash, and deducted from his cash account. In this manner but little ready cash was needed, as the carpenters would be obliged to get goods before the cash was due—a collateral feature being that Ward gave his notes for the cash earned by his men, and if they wanted money he would send them to O.H. Thompson, Ward's broker at Detroit, who would shave them unmercifully."

Alexander Anderson was one of the "substantial and enterprising citizens of Marine City" and had "attained notable prominence among the builders of good, stanch steamers and sailing vessels," according to *History of the Great Lakes*. He was born in the township of Goderich, Huron County, Ontario, in 1845, and came from a long line of Scottish sailors and ship captains. After attending school, he learned to be a carpenter and joiner, and when he had mastered all the details of the business, he became a contractor and builder, which positioned him well to enter the shipbuilding trade. In his earlier years, he was hired by shipbuilder John J. Hill of Marine City and assisted in the construction of many vessels. In 1882, he constructed the passenger steamer *R.J. Gordon*, followed by the *J.W. Westcott*, and overhauled various other vessels in the yard of Robert Holland. He went on to establish his own shipyard.

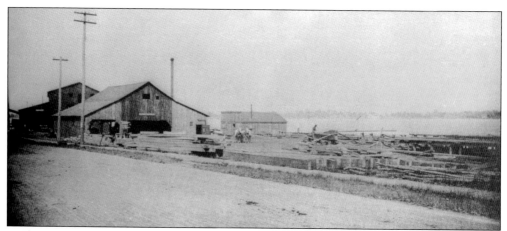

Anderson established his shipyard at the foot of Broadway on the east side of Water Street on the St. Clair River in 1890. Between 1879 and 1902, he built many ships, including his namesake schooner barge, *Alexander Anderson*, in 1892. *The Fifteenth Annual Report of the Bureau of Labor and Industrial Statistics*, published by the State of Michigan in 1898, described his business this way, "From 1890 until the present time twelve vessels, together having a valuation of $387,000, have been built and launched. . . . When running full, 150 persons, with an average monthly pay roll of $5,500, are employed. Mr. Anderson has been very successful in all his investments and has a national reputation for shipbuilding."

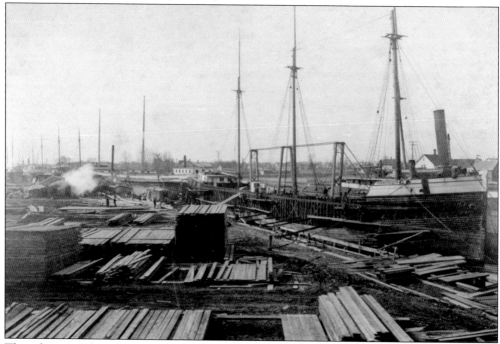

The schooner *Alexander Anderson* is shown here being replanked at Anderson's shipyard. She had her final enrollment surrendered at Port Huron, Michigan, in 1917 and was endorsed as a "total loss, waterlogged." Before the development of coal- and wood-fired steam engines, principal building centered on small fishing boats and schooners. Generally, these large wooden vessels featured two masts carrying two principal sails supported by booms and gaffs and had one or more triangular headsails rigged to a bowsprit.

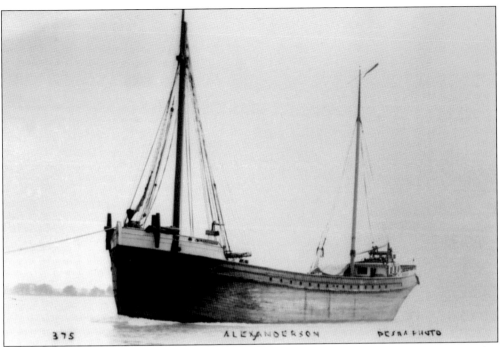

For many years, the *Alexander Anderson* ran for the Mills Transportation Company of Marysville, Michigan. Loaded with a cargo of pulpwood, she was lost when she foundered in a 60-mile-per-hour northwest gale off Sable Island, Nova Scotia, on a voyage from Chatham, New Brunswick, to Portland, Maine, in October 1916. She was in tow of the propeller *Gettysburg*, along with the schooner-barge *Arenac*. All three vessels were lost, but their crews were rescued.

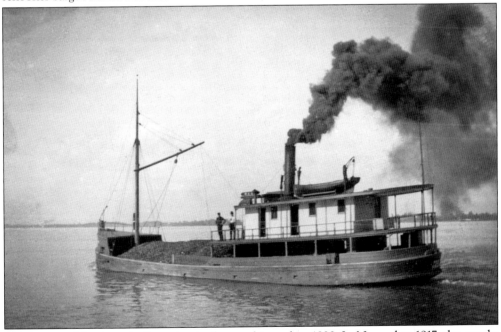

The steamer *Maud* was built at the Anderson shipyard in 1899. In November 1917, she caught fire and burned to a total loss while docked in St. Clair, Michigan.

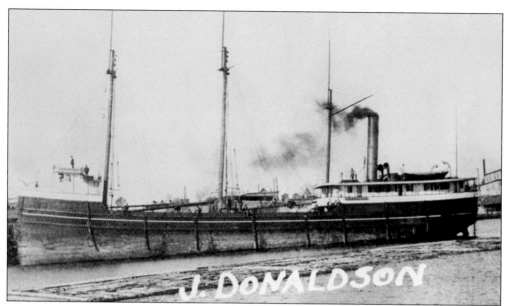

Anderson built the steamer *James P. Donaldson* in 1880 to serve as a coal and lumber carrier. She often towed the schooners *A. W. Wright* and *Dayton*.

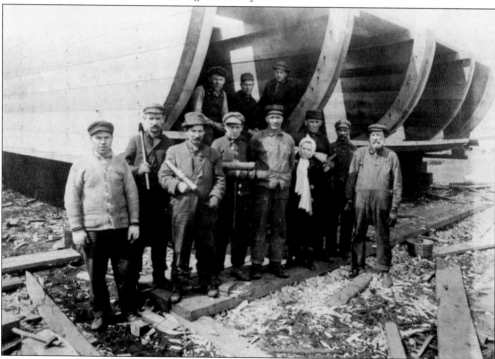

A group of shipwrights and carpenters poses at the Lester shipyard in front of a hull in progress. The construction of ships necessitated large quantities of nails, oakum for caulking, barrels of tar and pitch for making the hull water-tight (also known as "paying"), rope, paint, and linseed oil. As part of the caulking and paying process, a slurry mixture of manure and sawdust would be pumped into the hull of a vessel to seal leaks. Marine City's early shipbuilding industry was fueled with wood from the prosperous and abundant local lumber industry.

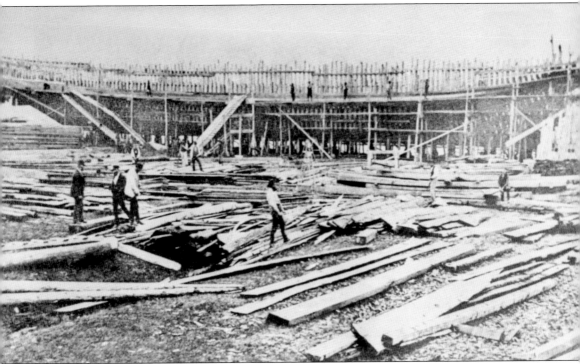

Built by Capt. David Lester in 1874, the steamship *V.H. Ketchum* is shown in the stocks at Lester's shipyard. The February 25, 1874, *Port Huron Daily Times* reported, "The largest vessel ever built on the lakes is being readied at Marine City under David Lester's supervision. She is 260 feet over all, 235 keel, 41 feet beam and 24 foot depth of hold, 7-8 feet between decks, 141 frames between stem and stern and over 50 streak of plank on either side, inside and out, over 120,000 feet of seams to be caulked or about 23 miles in length and requires 8,750 pounds of oakum. Three hundred barrels of salt have been used about the hull for the preservation of the timber. To complete the work will require about 10,000 days labor or work of 75 men for 9 months." On April 16 of that year, thousands gathered to see her launched, as this behemoth was 20 feet longer than any vessel previously built for the Great Lakes.

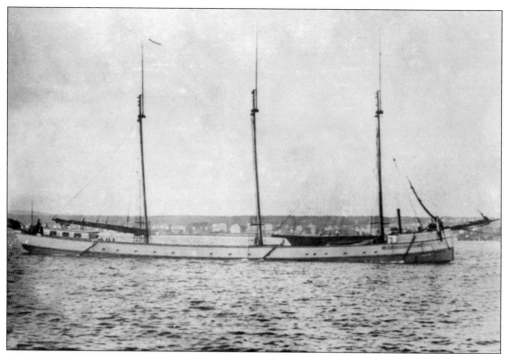

The schooner *Carrier* was built by David Lester in 1865. In her later years, she was used as a clubhouse by the Lincoln Park Club of Chicago, Illinois, in Belmont Harbor before being donated in 1923 to the Naval Reserve in Milwaukee, Wisconsin. While being towed to Milwaukee in September 1923, she became waterlogged and sank five miles out from Chicago.

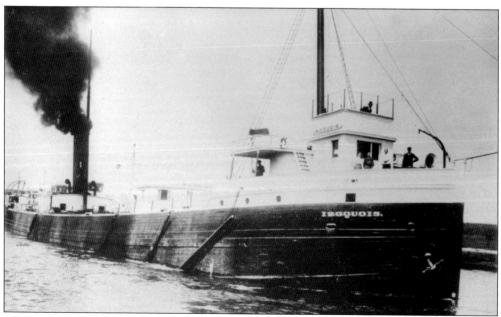

The steamer *Iroquois* was built in 1892 at the Lester shipyard. Her name was changed to the *Windsor* in 1907, and she was later abandoned in 1923.

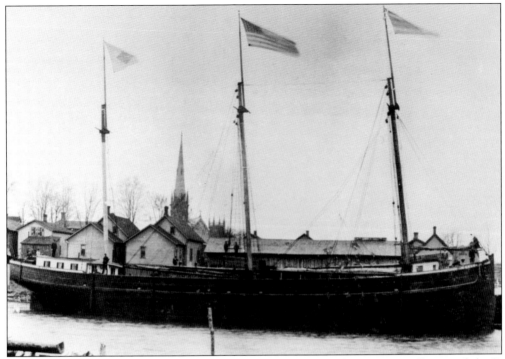

The schooner *William Brake* was built by David Lester in 1867. She was originally named the *S. Gardner* and was built to be a barge, but she had her rig changed to a schooner in 1884. She was abandoned as "unfit for service" at Port Huron, Michigan, in 1916. The steeple of Holy Cross is visible in the center background.

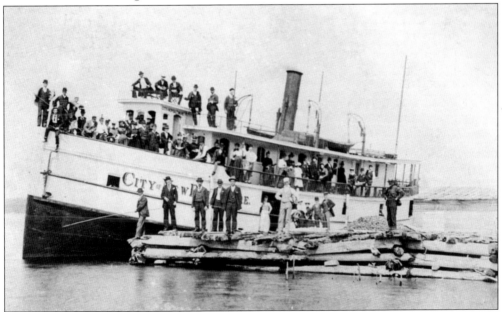

The ferry *City of New Baltimore* was built by David Lester in 1875, had her rig changed to a "tug" in 1910, and was abandoned in 1916. Challenging modern-day notions of safety, here she is shown with a full load of passengers ready to set sail.

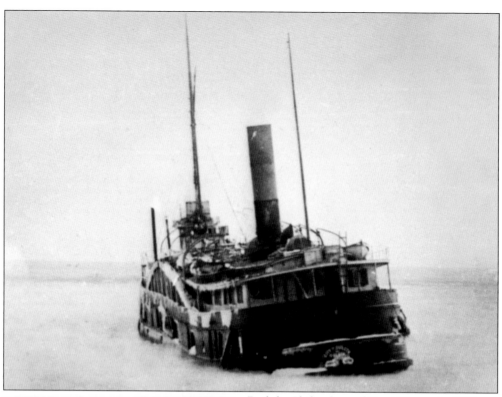

Built by Philander and David Lester in 1874, the passenger steamer *City of Duluth* is shown stranded in shallow water outside the piers at St. Joseph, Michigan, on Lake Michigan in January 1898. She was stranded while running the Chicago-to-St. Joseph route. Forty passengers and crew were rescued by the local life-saving station; the ship was a complete loss.

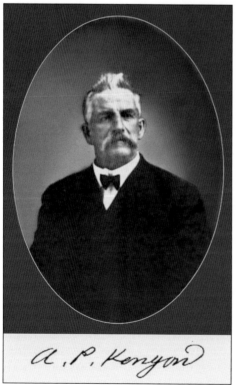

Born in China Township in July 1849, Capt. Alfred Phineas (A.P.) Kenyon bought his shipyard from Curtis and Brainerd in 1901. He specialized in steam barges and naptha launches, which were motorboats powered by a small engine with a boiler that burned naptha, a flammable liquid derived from peat, with similar properties to gasoline. Kenyon's daughter Grace was the wife of Frank Christian, the locomotive engineer who ran the first steam engine over the rails into town. A.P. passed away on December 2, 1920, in Marine City and was buried at Woodlawn Cemetery.

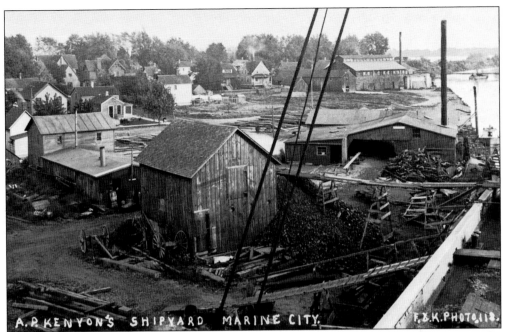

Founded in 1901, A.P. Kenyon's shipyard was located on the east side of the Belle River at the end of Mary and Washington Streets. According to *St. Clair County, Michigan, Its History and Its People* by William Jenks, "His facilities for doing the work are of the best and his workmen cannot be excelled for skill and careful attention to detail. The place presents at all times an exceedingly busy appearance and is a most interesting one to visit. A great deal of repair work is done and during the past ten years. Captain Kenyon has turned out ten lighters, four yachts, four steam barges and also twelve life boats, which were placed on steamers that plough the waters of the Great Lakes." (Photograph by F. & K.)

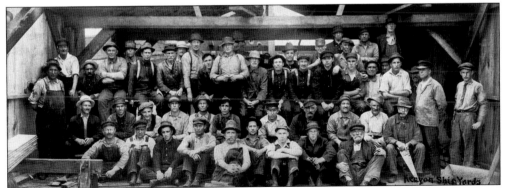

This crew of ship builders poses at the Kenyon shipyard probably sometime between 1880 and 1890. The typical shipyard consisted of a plot of land near the water with a few shipways, a shop for yard tools, and enough space to store timber.

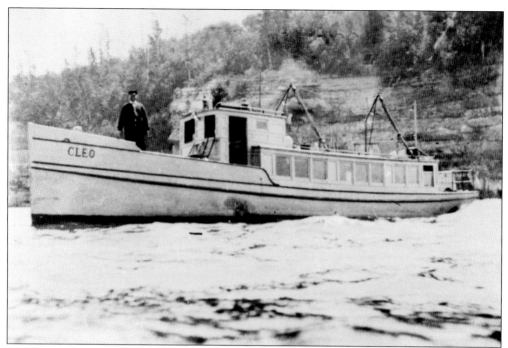

The *Cleo* is shown near Au Sable, Michigan. She was built by A.P. Kenyon in 1909 to serve as a patrol boat for the State of Michigan Department of Game, Fish, and Forestry. *Cleo* was owned by the state until 1928, when she was sold to a private party and converted to a fishing rig.

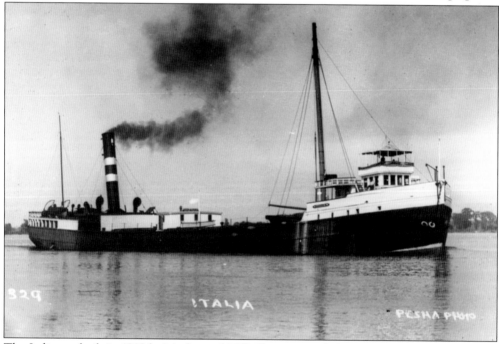

The *Italia* was built in 1889 by Morley and Hill. She surpassed the *V.H. Ketchum*, built in 1874 and once considered the largest ship on the Great Lakes, by 19 feet. The *Italia* sailed the Great Lakes for many years and was abandoned in 1915.

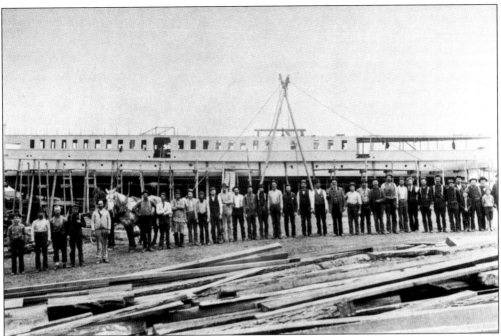

This crew poses in front of the steamer *Unique* as it is being built at the Holland shipyard at the foot of Pearl Street on the St. Clair River in 1893. The steamers *Unique* and *Mary* were built for Crocket McElroy and were used in the passenger trade between St. Clair and Detroit. The *Unique* was put into service in May 1895 and was known for her fast passages. In 1915, she blew a boiler in New York Harbor, killing the fireman and throwing another man overboard to drown.

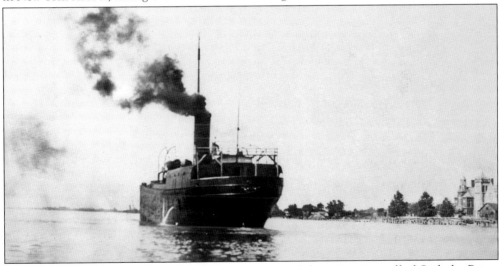

The stern of the steamer *Mataafa* is shown being towed downriver just off of Catholic Point. Built as the *Pennsylvania* by the Cleveland Ship Building Company in Lorain, Ohio, in 1899, the *Mataafa* struck the piers at Duluth Harbor in Duluth, Minnesota, on November 28, 1905. It was the worst storm ever seen on Lake Superior in modern times up to that point. She broke in half, and nine of the crew froze to death in the brutal waters. The Mataafa Storm, named after the *Mataafa* wreck, ended up destroying or severely damaging 29 vessels, killing 36 seamen, and causing property losses of approximately $1.75 million.

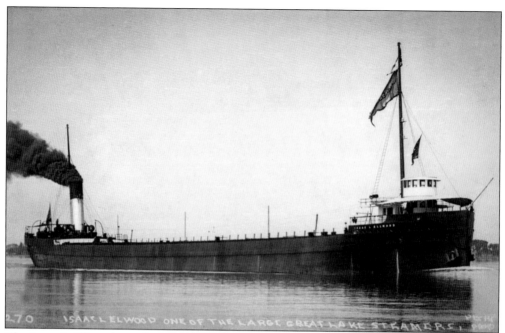

The *Isaac L. Ellwood* travels downriver at Marine City. The *Ellwood* was built in 1900 by the West Bay City Ship Building Company of West Bay City, Michigan, for the American Steamship Company of Duluth, Minnesota. Also a victim of the Mataafa Storm, the *Ellwood* was thrown against the north pier at the Duluth Canal while entering Duluth Harbor, along with the *Mataafa*. The *Ellwood* sank in the harbor, while the *Mataafa* broke in two.

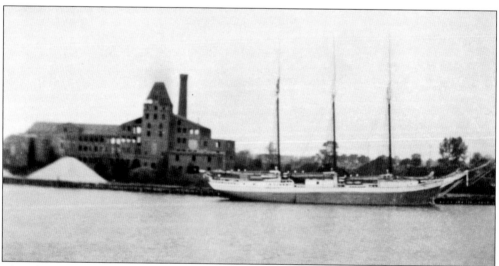

The schooner *J.T. Wing* is seen here in front of the old sugar plant, clearly abandoned at this point. The *Wing* was built in 1919 in Nova Scotia and was originally named the *Charles F. Gordon*. After being laid up in the Belle River in 1943, she was towed to Belle Isle in the Detroit River and converted to a land-locked museum in 1946. She was intentionally burned down in 1956 to be replaced with the Dossin Great Lakes Museum.

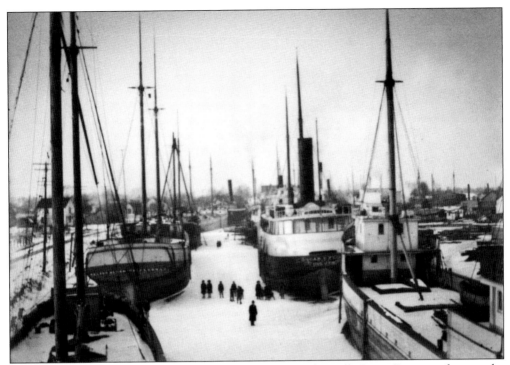

In 1896, a number of ships were laid up for the winter on the Belle River. Because of ice on the Great Lakes, the navigational season did not go year-round, and most boats were laid up for maintenance and repair. According to the *Report of the Chief Engineers of the U.S. Army* from 1880, "Marine City is the depot of an extensive tract of fine oak timber suitable for shipbuilding and vessel repairs, and hence ever since there has been any commerce on the Great Lakes has been a favorite place for laying up vessels for the winter, as they could there be berthed and receive necessary repairs at a cheaper rate than at their several ports of hail."

During the winter of 1889, this ice jam on the Belle River between the upper and the lower bridges trapped the steamers *Harvey J. Kendall*, the *Toltec*, and the *Tempest*.

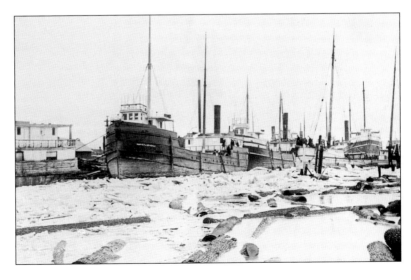

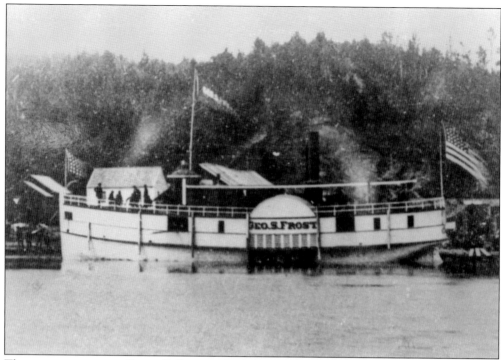

The passenger steamer *George S. Frost* was built by Joseph Luff at Marine City in 1868. She was lost to fire at Erie, Pennsylvania, in September 1879.

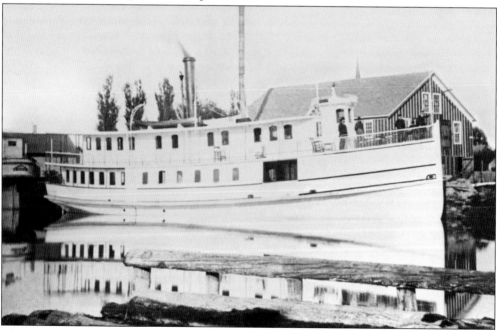

The passenger steamer *Pickup*, built in 1883 at Marine City, once picked up passengers at remote points and brought them to the main lines. This photograph was taken on the Belle River just south of the lower bridge. The steeple of Holy Cross Church on Bridge Street can be seen above the center of the stave-drying shed.

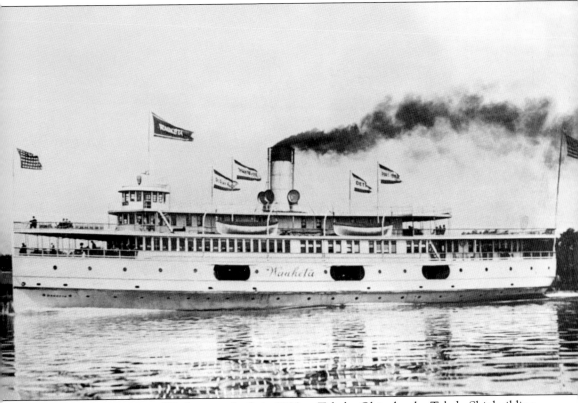

The passenger steamer *Wauketa* was built in 1908 at Toledo, Ohio, by the Toledo Shipbuilding Company. *Wauketa* was built for the White Star Line to run between Toledo, Detroit, and Port Huron, with stops at Tashmoo Park and the St. Clair Flats. She made daily stops in Marine City to pick up passengers for these pleasure excursions. In 1929, she was bought by a New York company to run the excursion trade around New York and Long Island Sound.

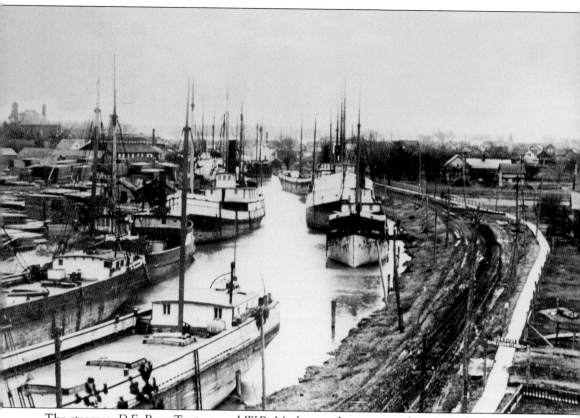

The steamers *D.F. Rose*, *Tempest*, and *W.B. Morley* are shown moored in the Belle River. The *W.B. Morley* was built in Marine City by Morley and Hill in 1892. It sailed the Great Lakes until 1921, when she had an accident on the St. Lawrence River and was condemned and dismantled. Mathew Sicken's Planing Mill and Lumber Company and Holy Cross Church are seen in the left background. At the bottom right, the sign over the wooden sidewalk reads, "O.M. Quick Marble & Granite Works."

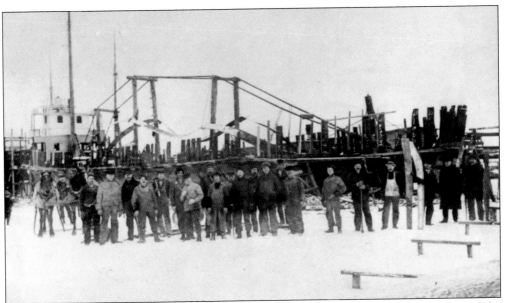

Built by Rieboldt and Wolter in Sheboygan, Wisconsin, in 1890, this crew poses in front of the steamer *John Schroeder*, later renamed the *William A. Hazard*, while being renovated at one of the shipyards on the Belle River. The busiest time of year for ship construction and repair was in the late winter and early spring. Sailors who were idled by the close of the shipping season joined with the professional ship carpenters and caulkers to finish vessels before the shipping season began again in late spring.

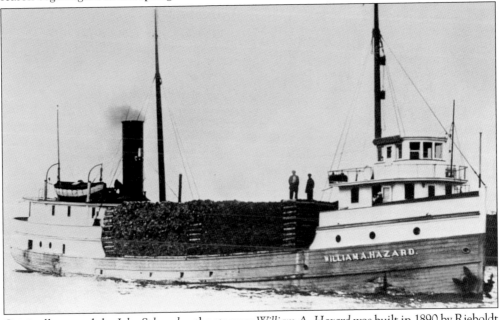

Originally named the *John Schroeder*, the steamer *William A. Hazard* was built in 1890 by Rieboldt and Wolter of Sheboygan, Wisconsin. The ship originally functioned as a lumber and coal carrier but was later converted to a sand boat. For many years, she was sailed by Capt. R. Beattie of Marine City, Michigan. She was named for William Hazard, who was the president and director of the Michigan Salt Works.

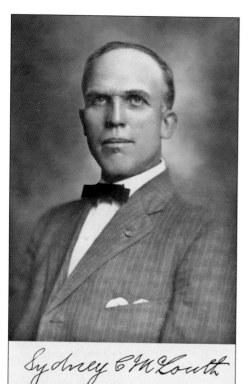

Sydney C. McLouth was born in Pittsford, Michigan, in 1862. As a young man, he divided his time between the lumber camps in winter and employment on Great Lakes boats during the summer shipping season. Between 1881 and 1894, he held the position of chief engineer. Also, McLouth occupied a number of political offices through the years. He served as mayor for four years, served on the board of aldermen for four years, and held a seat on the school board for six years. McLouth was the original owner of the Michigan Salt Works, which he purchased from the National and Germania Salt Company. In 1910, he purchased the Lester and Roberts shipyard. McLouth died in 1923, and his son Peirce continued to run the family business.

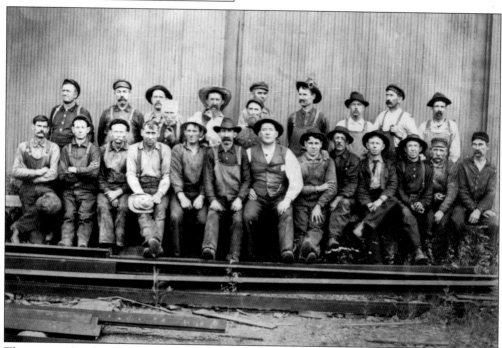

This group of workmen breaks from a rigorous day to pose for a photograph at McLouth Shipyard sometime around 1910. The carpentry skills required of shipwrights or shipbuilders were almost exclusively obtained through on-the-job training.

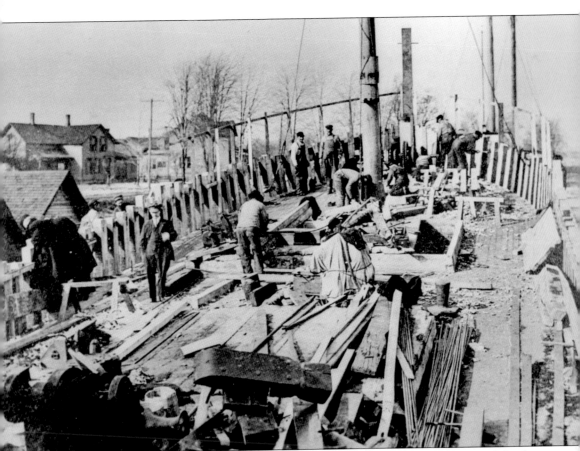

Another crew is seen hard at work at McLouth Shipyard. Typically, hardwood was used for the keel, and huge timbers were bolted together. While the keel was being laid, workmen built and shaped the stern and sternpost and the frames of the vessel. When finished, the frames were raised along the length of the keel, the floor frames were bolted on, and the stern and sternpost were fitted in place using scarphs and aprons for support. When the skeleton of the vessel was complete, she was said to be "in frame," and the addition of strengthening timbers could begin. The keelson, a heavy timber, was laid over the top of the floor frames, running the length of the keel, and bolted to the keel through the frames. A vessel was planked from the keel upwards, with slightly thicker planking being used below the waterline. Planks were steamed in a "steam box" at the shipyard, making them more pliable, and then twisted and bent as swiftly as possible into the shapes necessary to fit them onto the frame of the vessel. They were attached using iron bolts and wooden nails, or treenails, which would swell to a tight fit once in the water.

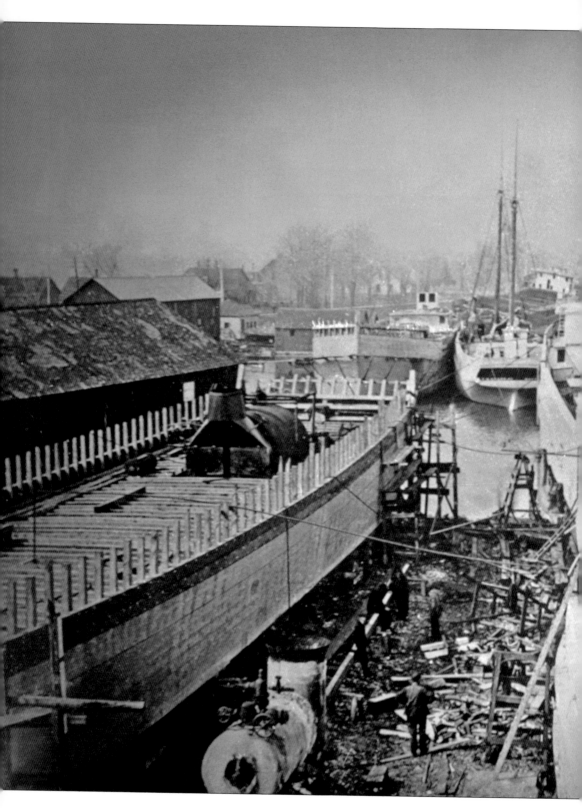

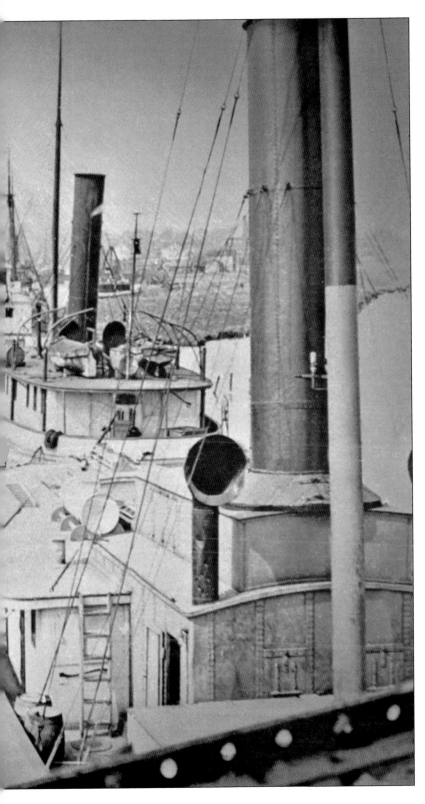

Looking north toward Holy Cross Catholic Church, steamers and schooners can be seen in the McLouth Shipyard at the Belle and St. Clair Rivers. To the left is a partially constructed steamer with its boiler clearly visible. During the turn of the century, wooden ships—both steam and sail—made up the bulk of the Great Lakes commercial fleet.

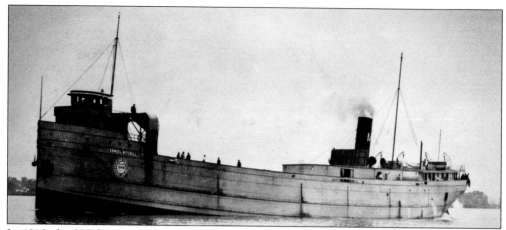

In 1916, the 292-foot ore carrier *Samuel Mitchell* was converted into the Great Lakes' first self-unloading bulk cement carrier at McLouth Shipyard when she was equipped with a new unloading device consisting of a motor-operated "worm." This worm featured a system of buckets that ran on an endless chain from the bottom of the boat to the chute above the deck, through which the bulk cement was loaded into storehouse bins. Openings in either side of the hopper bottom allowed the cement to drop below to the worm's constantly revolving spirals, which forced the cement forward until it fell into the buckets that eventually carried it above deck for unloading.

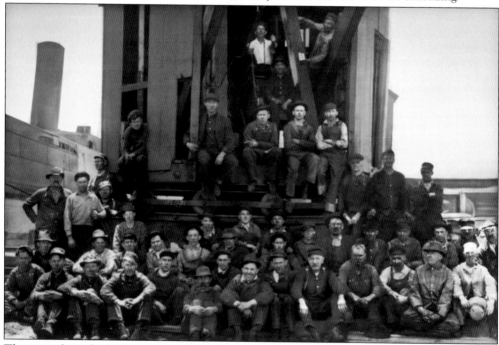

The crew that rebuilt the steamer *Samuel Mitchell* poses on a crane. From left to right are (first row) unidentified, Norman Streublig, Henry Joseph, three unidentified, Joseph Durand, Frank Belanger, William Boulier, three unidentified, Capt. W.W. Shorkey, and George Perrin; (second row) two unidentified, David Blanchard, unidentified, Clarence Bulley, Michael Rooney, and Edward Durrow; (third row) three unidentified, ? Biscorner, Russell Black, Robert Day, unidentified, and ? Jones; (fourth row) Arthur Fetting, two unidentified, Morgan Thomas, and unidentified; (fifth row) Albert Arnold and two unidentified.

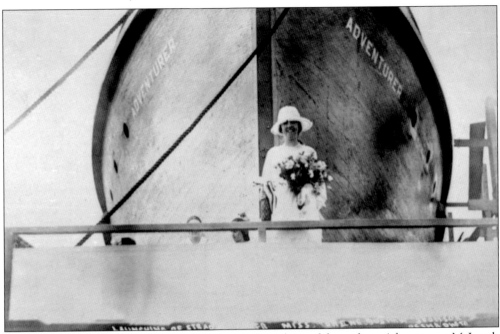

Norene Bashaw poses for a photograph before the launching of the tugboat *Adventurer* at McLouth Shipyard in July 1919. In 1917, the United States entered World War I, which had been raging in Europe since July 1914. It quickly became apparent to the US Shipping Board (USSB) that the country would not have enough ships to bring supplies, food, and ammunition to support overseas troops, especially considering the effectiveness of German U-Boats. The Emergency Fleet Corporation (EFC)—also referred to as the War Shipping Board—decided to contract 703 wooden cargo steamships to supplement its budding fleet of steel cargo ships.

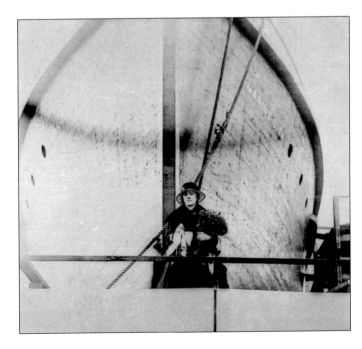

Charlotte F. Armsbury prepares to christen the tug *Marine City* for its launching at McLouth Shipyard on December 1, 1919. In 1918, the federal government awarded McLouth a $2.5 million contract to construct nine ocean-going wooden tugs to support the war effort, which would soon end with a cease-fire on November 11, 1918, later known as Armistice Day. After the armistice was declared, work under the contract was suspended.

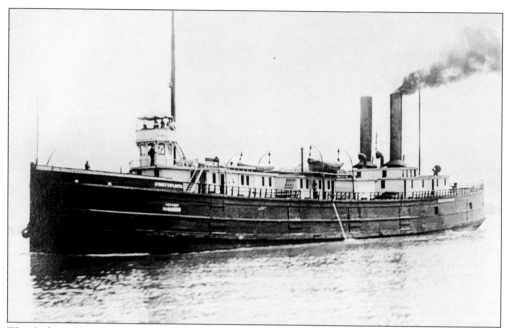

The *Sydney C. McLouth* was built by the Union Dry Dock Company of Buffalo, New York, in 1880, and was originally named the *Rochester*. She was purchased by McLouth and renamed in 1906. In June 1912, she caught fire and burned to a total loss eight miles northeast of Pensaukee, Wisconsin, shortly after departing from Green Bay. Capt. W.W. Shorkey and his crew of 15 rowed their lifeboats back to safety in Pensaukee.

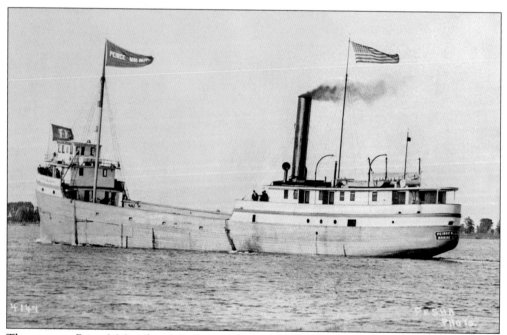

The steamer *Peirce McLouth* was built in 1880 as the *W.H. Gratwick* by the Detroit Dry Dock Company in Detroit. Sydney McLouth purchased her in 1918, rebuilt her, and named her after his son Peirce, who ran the shipyard for years after his father's death.

The steamer *Langell Boys* was originally built in 1890 by Simonn Langell in St. Clair, Michigan. She is shown here being rebuilt at the McLouth Shipyard. Holy Cross Catholic Church can be seen in the center background.

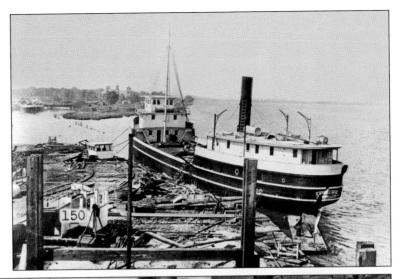

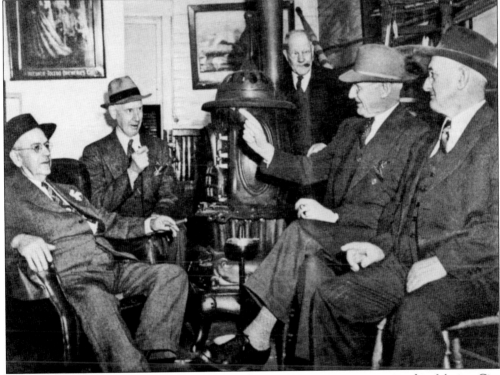

The Marine City Lodge No. 8 of the Ship Masters' Association was organized in Marine City in 1892. In the winter season, weekly meetings were held every Tuesday evening in Hermann's Hall to discuss admiralty law, new instruments, and safety issues. The lodge's first elected officers were Capt. T.S. Walker, president; Capt. Edward Allum, vice president; and Capt. W.H. Scott, secretary. The group was very active in the community and sponsored dances at city hall. These ship captains are seen gathered sometime during the 1930s to tell stories of sailing adventures on the Great Lakes. From left to right are L.J. Lavely, G.T. McDermott, Henry Holland, Daniel Murphy, and L.B. Conlin. The association also had a meeting room above Zimmermann's Hardware, where they would meet to study for their advancement in rating.

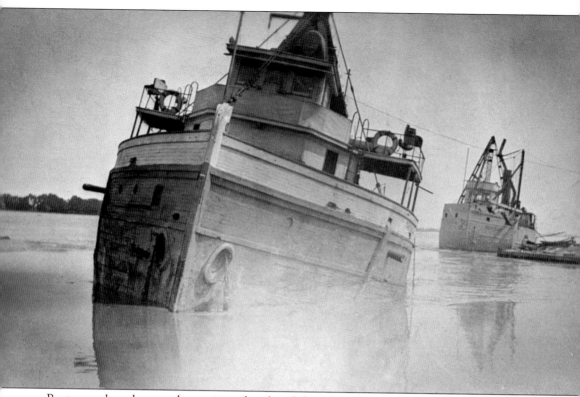

Boats were born here, and sometimes they found their final resting place here. Built in 1894, the steamer *Marysville* burned and sank at the mouth of the Belle River in 1928. The steamer in the background is believed to be the *Kalkaska*.

Three

L. PESHA
MARINE PHOTOGRAPHER

Louis James Pesha was born on August 11, 1868, at Euphemia, Ontario, where he grew up and worked on a farm until he was 27 years old. Sometime around 1895, Pesha learned photography and over the years set up studios and galleries in his Canadian homeland at Alvinston, Inwood, Oil Springs, and Brigden, Ontario. In 1892, Louis married Lena E. Fancher of Santena, Illinois. Their only child, Lorraine, was born in 1901. Louis settled his family in Marine City in 1901, where he established the Pesha Postcard Company and the Pesha Art Company to photograph the "big boats" on the St. Clair River. His shop was located at the north end of the present-day waterworks plant, the current location of the servicemen and firefighter monuments.

Pesha brought photography to the common man in the form of postcards, which were essentially pieces of "art" that anyone could afford. He built a successful business out of selling these all over the country by way of classified ads in the back of magazines and journals. Besides building a very impressive collection of freighter and other vessel photographs, some of his cards employed trick photography to show fantastical scenes, such as a man with a giant corncob on his back or a biplane towing a passenger steamer. Others had romantic themes, like two lovers in a car with a caption reading, "The Clutch is Working Tight." There is no definitive count for the number of pictures he took, as most of his original glass negatives have been lost, broken, or destroyed.

Sadly, Louis Pesha met his demise on October 2, 1912, at the young age of 45, when he was crushed by his White Steam Car while on a visit to his parent's farm in Euphemia, Ontario. The car rolled backwards over a steep embankment, overturned, and killed him instantly. Pesha left behind his wonderful photographic legacy as well as his wife, Lena, who skillfully carried on his trade.

Unless otherwise noted, the photographs in this chapter are credited to either Louis Pesha or the Pesha Postcard Company.

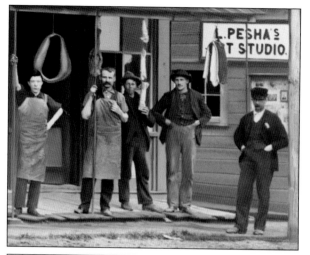

This c. 1900 photograph, an enlarged section of a bigger image, shows local shop owners in front of their shops in Oil Springs, Ontario. It would be reasonable to believe that Louis Pesha is photographed here under the sign stating, "L. Pesha's Art Studio" to the right of the harness makers, however there is no documented proof that this is indeed him. Rather, it stands to reason that, more likely, Pesha would have been the actual photographer who took the picture. Perhaps this gentleman under the sign was his employee.

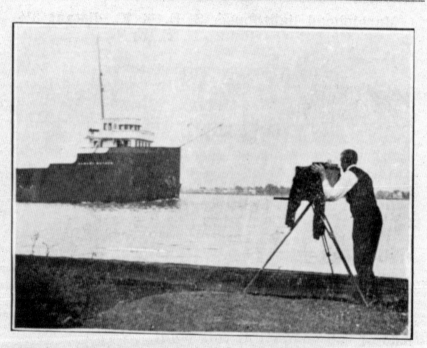

PESHA at **MARINE CITY** photographing the big boats as they pass at full speed. Phone him your order, any day except Saturday. Photos taken from on the river in forenoon, from on the shore in afternoon, on account of the sun.

Originally published as an advertisement in the 1907 issue of *The American Pilot and Engineer*, this is the only authenticated picture of Pesha. The advertisement reads, "Pesha at Marine City photographing the big boats as they pass at full speed. Phone him your order, any day except Saturday. Photos taken from on the river in forenoon, from on the shore in afternoon, on account of the sun." Pesha was a Seventh Day Adventist, hence he did not work on Saturdays. (Courtesy of the Library of Congress.)

MARINE PHOTOGRAPHER

Large Photos and Post Cards of all Lake Boats can be had from

L. PESHA

MARINE CITY - - - MICH.

Pesha took advantage of advertising in a variety of publications of his day, such as *Beeson's Marine Directory, Popular Mechanics,* and the *Ship Master's Association of the Great Lakes Directory,* as shown in this April 1907 issue. He advertised as the Pesha Art Company and as L. Pesha with the title "Marine Photographer."

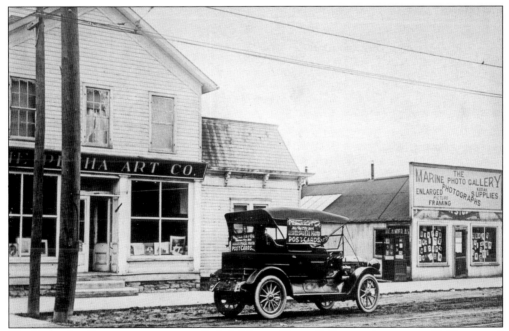

The Pesha Art Company was next to Pesha's Marine Photo Gallery at the corner of Jefferson and Water Streets. The Marine Photo Gallery sold photograph enlargements, picture framing, and Kodak supplies, which most likely included the low-priced, point-and-shoot, hand-held Brownie camera and film.

Parked in front of his shop, this is the 1910 White Steam Car that Pesha was driving at the time of his death. Thomas H. White, the owner of the White Sewing Machine Company founded in Boston, Massachusetts, in 1858, started the White Motor Company in 1905. The White Steam Car was more expensive than a Rolls Royce and was the first official automobile of the White House under Pres. Theodore Roosevelt. After building over 9,000 steamers, production of White Steam Cars stopped in 1910.

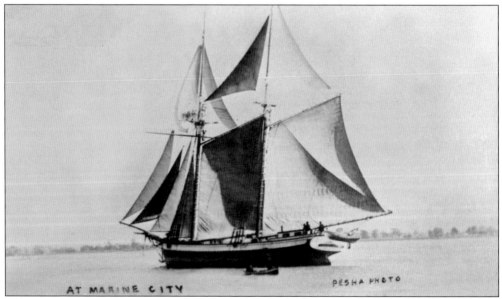

AT MARINE CITY PESHA PHOTO

Pesha did much of his work from his own backyard on the St. Clair River, where he photographed both the "old" era of Great Lakes shipping, like this schooner, as well as the "new" era of wooden and, later, steel-hulled steamers. Ships are like people, as each one has its own unique identity: a "birth," a "life," and a "death." Pesha photographed vessels at specific moments in time before they sailed off to the rest of their life's story.

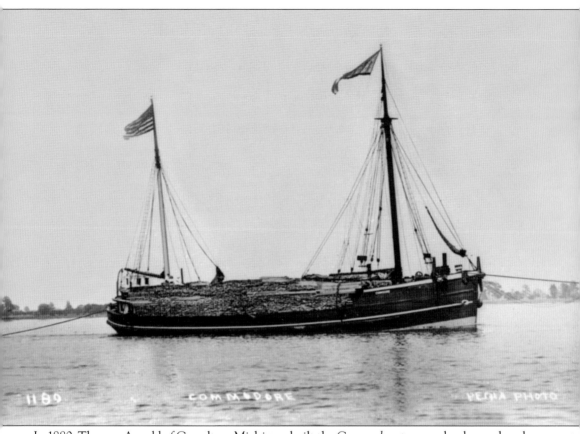

In 1880, Thomas Arnold of Carrolton, Michigan, built the *Commodore* to carry lumber and coal. She sank in June 1918 about 10 miles southeast of the Southeast Shoal Light on Lake Erie. After towing the propeller *Jay Gould* with cargoes of coal from Cleveland, Ohio, to Sandwich, Ontario, she sprang a leak and foundered. Her crew was rescued by the steamer *Mataafa*.

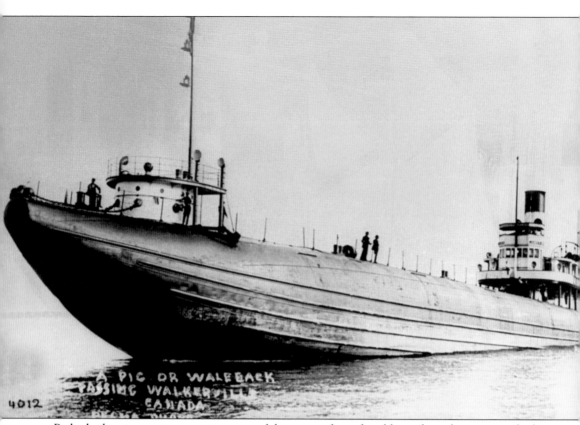

A PIG OR WALEBACK
PASSING WALKERVILLE
CANADA

4012

Pesha had an interest in a great variety of ship types, from the old wooden schooners, to the big steel-hulled package freighters, to the wonderfully nicknamed "pig," "whaleback," or "cigar boat" steamers. Here, the whaleback steamer *James B. Neilson* passes Walkerville, Ontario.

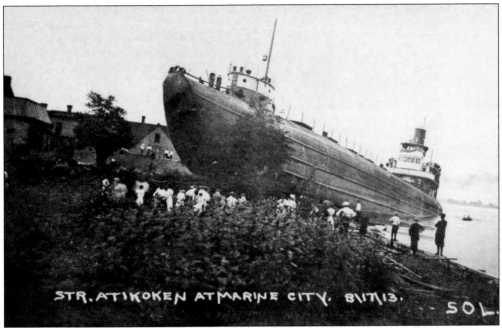

STR. ATIKOKEN AT MARINE CITY. 8\17\13. SOL.

On August 17, 1913, the whaleback steamer *Atikokan*, misspelled here as "Atikoken," ran aground by Jefferson and Water Streets just north of the modern-day waterworks. (Photograph by Sol Foster.)

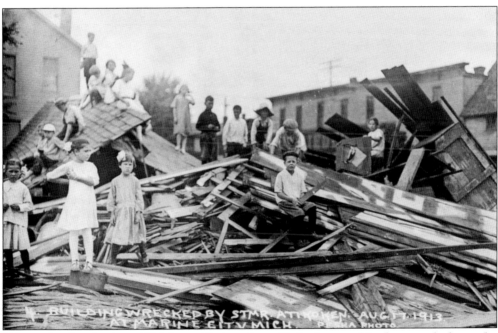

BUILDING WRECKED BY STMR. ATIKOKEN. AUG. 17.1913. AT MARINE CITY MICH. PESHA PHOTO.

Taken after his death in 1912, but still signed as a Pesha image, this photograph shows the remains of Pesha's old boathouse on his property on the St. Clair River after it was struck by the whaleback steamer *Atikokan*.

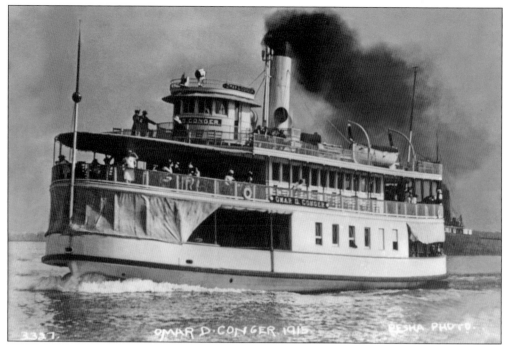

The 92-foot excursion steamer *Omar D. Conger* was built in 1882 by George Hardison of Port Huron, Michigan, for the Port Huron-Sarnia Ferry Company. In 1922, she was completely destroyed by a boiler explosion while docked in the Black River in Port Huron. Probably caused by an overheated boiler, the explosion killed four crewmen, injured dozens more on shore, and damaged and destroyed several buildings.

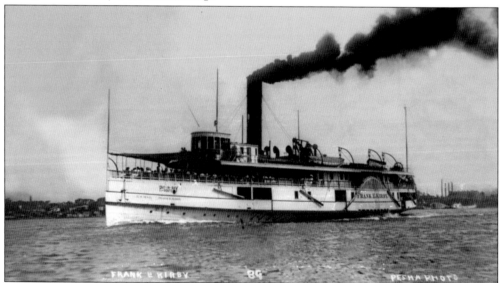

The iron-hulled, side-wheel passenger ferry *Frank E. Kirby* was built in 1890 by the Detroit Dry Dock Company in Wyandotte, Michigan. She was known as the "flyer of the lakes" and was designed by the *Kirby's* namesake, the famous naval architect from Detroit who also designed grand passenger ships such as the *City of Detroit III*, the *Columbia*, the *Greater Detroit*, the *Ste. Claire*, the *Tashmoo*, and the *Seeandbee*.

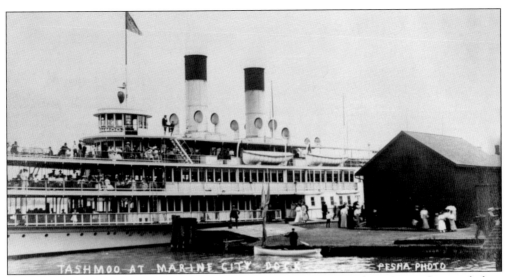

Pesha photographed many ships that passed by his studio or stopped at Marine City, including the grand passenger excursion steamer the *Tashmoo*. In 1900, the *Tashmoo* was built by the Detroit Ship Building Company in Wyandotte, Michigan, for the White Star Line. Her regular route ran from Detroit to Port Huron, Michigan. It made several stops along the way, including at its namesake, Tashmoo Park. Because of her speed, she was nicknamed the "White Flyer" and, because of the number of windows on the ship, the "Glass Hack." The structure to the right later became the US Border Patrol and Customs building.

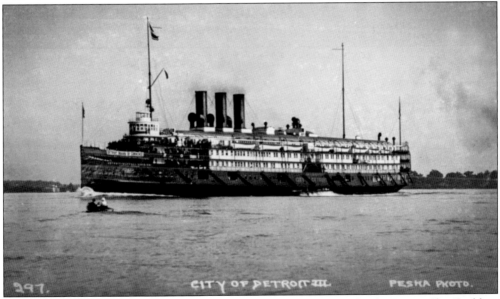

Designed by famous marine architect Frank E. Kirby and built in 1912 by the Detroit Ship Building Company in Wyandotte, Michigan, for the Detroit and Cleveland Navigation Company, the *City of Detroit III* was a side-wheeler steamboat that traveled regularly between Detroit, Michigan; Cleveland, Ohio; and Buffalo, New York. It was the largest side-wheeler on the Great Lakes until the following year when a competing steamship company, the Cleveland Buffalo Transit Company (C and B), launched the 485-foot *Seeandbee*. Launched the same year Louis Pesha died, this photograph may have been taken by him or, possibly, by his wife, Lena.

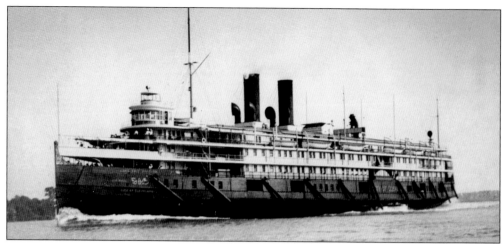

The passenger steamer *City of Cleveland* was built in 1907 by the Detroit Ship Building Company of Wyandotte, Michigan, for the Detroit and Cleveland Navigation Company of Detroit. She was actually the fourth passenger steamer to be named *City of Cleveland*. Upon being built in 1907, she was destroyed by fire in Wyandotte, but she was immediately rebuilt and put back into commission in 1908. On June 25, 1950, while on a cruise with the Benton Harbor Chamber of Commerce, she collided with the Norwegian freighter *Ravnefjell* in a heavy fog off the coast of Harbor Beach on Lake Huron. Five passengers were killed in the accident, and she never sailed again.

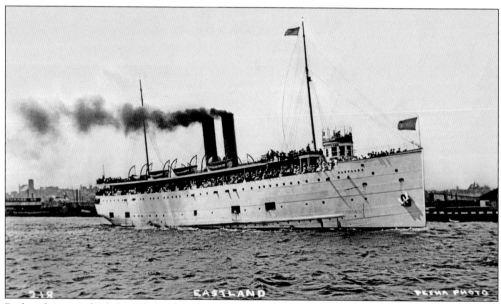

Pesha photographed the *Eastland* sometime before the disaster of July 24, 1915, on the Chicago River at the Clark Street Bridge in Chicago, Illinois, when she capsized and caused the death of 812 passengers. The boat was one of four chartered by the employees of the Western Electric Company to carry 7,000 men, women, and children on an annual outing to Michigan City, Indiana. With approximately 2,500 persons aboard, the boat was dangerously overcrowded, causing her to list several times before capsizing in 18 feet of water while still moored to the dock. Hundreds of passengers were trapped between decks and drowned or crushed to death, leaving behind many widows and orphans.

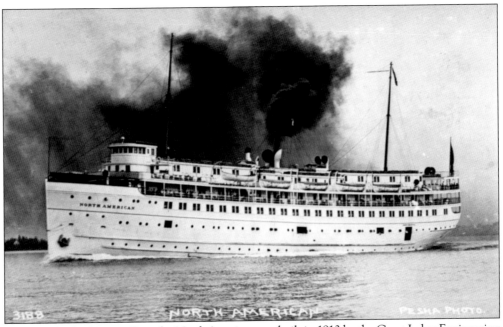

Photographed at Marine City, the *North American* was built in 1913 by the Great Lakes Engineering Works of Ecorse, Michigan. She and her fleet mate, the *South American*, were popular for overnight excursions in the upper Great Lakes (Huron, Superior, and Michigan). The *North American* had a second smokestack added in 1923. She was sold to the Seafarer's International Union in 1967 to be used as a training ship at Piney Point, Maryland. In 1967, while being towed to Maryland, she unexpectedly sank in the Atlantic Ocean in 400 feet of water 25 miles northeast of the Nantucket Light.

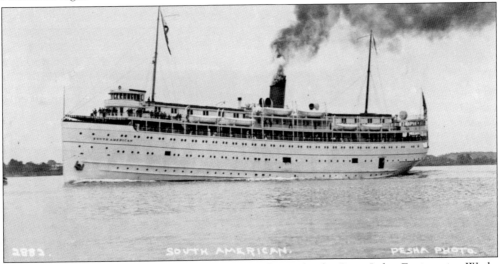

The *South American* was built in 1914 at Ecorse, Michigan, by the Great Lakes Engineering Works for the Chicago, Duluth, and Georgian Bay Transit Company. In 1924, she suffered a serious fire after laying up at Holland, Michigan. She was rebuilt and a second smokestack was added. In 1967, after the *North American* sank in the Atlantic Ocean, the Seafarer's International Union purchased her. After years of attempting to bring her back to the Great Lakes as a museum and restaurant ship, she was finally scrapped in 1992.

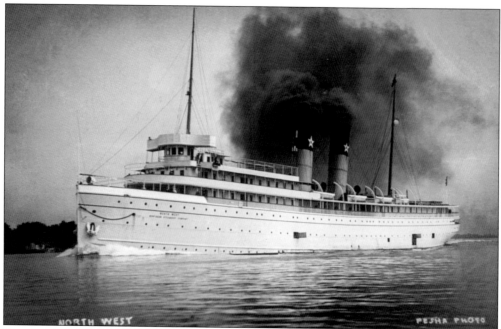

The passenger steamer *North West* was built by the Globe Ship Building Company of Cleveland, Ohio, in 1894 for the Northern Steamship Company of Buffalo, New York. In 1902, she was rebuilt and had her three smokestacks reduced to two. In 1911, she was gutted by a fire in Buffalo and was retired as a passenger steamer. In November 1918, she was cut in half for transport through the Welland Canal. While bound for Montreal, her forward half foundered in Lake Ontario, and two crew members were lost. In 1920, her name was changed to the *Maplecourt*. In 1941, while bound from Montreal to Great Britain, she was torpedoed by a German submarine about 300 miles west of the Hebrides Islands in the North Atlantic Ocean; her entire crew of 37 was lost.

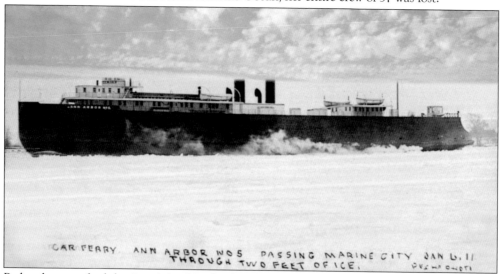

Pesha photographed the *Ann Arbor No. 5* railroad car ferry passing Marine City in January 1911. She barreled through two feet of ice back when the St. Clair River still froze solid. She was built in 1910 by the Toledo Ship Building Company in Toledo, Ohio, for the Empire Trust Company of New York and the Ann Arbor Railroad Company of Frankfort, Michigan.

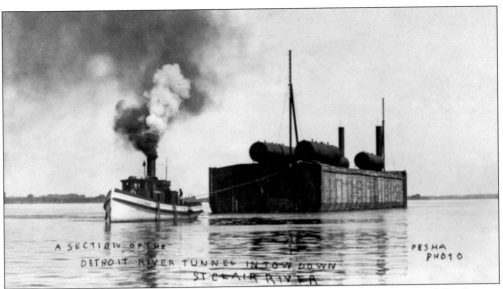

The tugboat C.A. *Lorman* of the Detroit Dry Dock Company tows a section of the Detroit River Tunnel on the St. Clair River. The Michigan Central Railway Tunnel under the Detroit River connects Detroit with Windsor, Ontario. Opened in 1910, it was built by the Detroit River Tunnel Company for the Canada Southern Railway and is still in use today by the Canadian Pacific Railway.

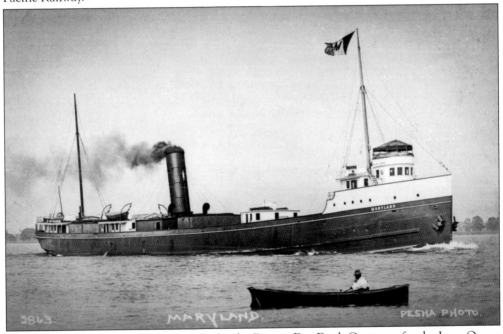

The steamer *Maryland* was built in 1890 by the Detroit Dry Dock Company for the Inter Ocean Transportation Company of Milwaukee, Wisconsin. In July 1907, she collided with, and sank, the *Tuscarora* in the St. Clair River near the entrance to Lake Huron. After her service on the Great Lakes, she was sent to the Atlantic Seaboard for ocean freight service. In December 1916, bound from Philadelphia, Pennsylvania, to London, England, she foundered in an extremely severe storm off of Nantucket Island, and the entire crew was lost.

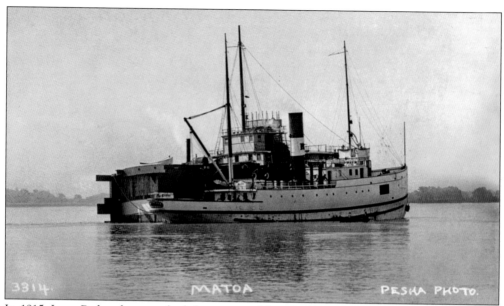

In 1915, Lena Pesha photographed the separated bow and stern of the *Matoa* being towed by the tugs *Sarnia City* and the *James Reid*. The *Matoa* was built in 1890 by the Globe Iron Works in Cleveland, Ohio, for the Minnesota Steamship Company. In 1915, she was sold by the Reid Wrecking Company of Sarnia, Ontario, to the Warren Transportation Company of Boston, Massachusetts, to be used for ocean service.

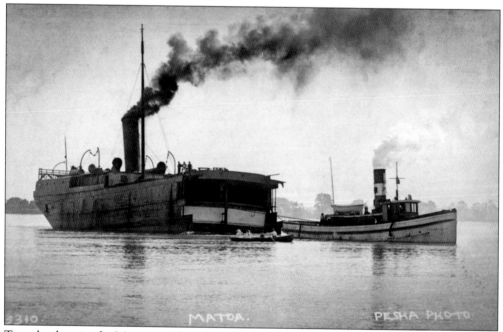

To make the trip, the *Matoa* would need to pass through the Welland Canal in the St. Lawrence Seaway. At the time, the largest boat that could pass through the canal was 257 feet long and 44 feet wide; the *Matoa* was 290.5 feet long. The July 1915 edition of *The American Marine Engineer, Volume 10*, reported that the she would be cut in half and "both sections . . . walked through . . . separately. The steamer will be taken to Quebec, where the two parts will be riveted together."

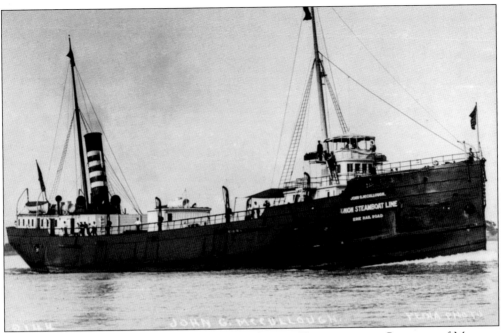

Originally named the *S.C. Reynolds* for the Lake Erie Transportation Company of Monroe, Michigan, the *John G. McCullough* was a steel package freighter built in 1890 by the Union Dry Dock Company of Buffalo, New York. In 1915, she was sold and rebuilt for ocean service. On her voyage from Buffalo to New York City, she had to have 12 feet of her stern severed to fit through the Welland Canal. In 1918, during World War I, she was torpedoed by a German UB-74 and sunk off the coast of France.

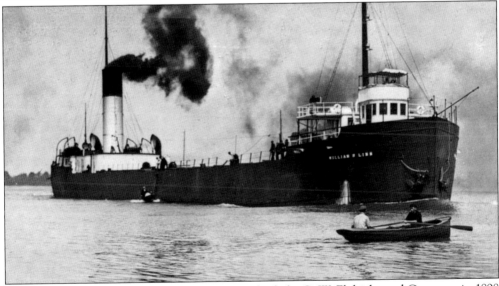

The 420-foot steel freighter *William R. Linn* was built for C. W. Elphicke and Company in 1898 by the Chicago Ship Building Company. In June 1906, during a heavy fog on Lake Huron, she collided with the 150-foot wooden steamer *New Orleans*. The *Linn* tore a hole in the side of the *New Orleans*, causing her to founder and sink within 10 minutes; her crew escaped to safety aboard the *Linn*. The *New Orleans* sits in 150 feet of water off the coast of Alpena, Michigan.

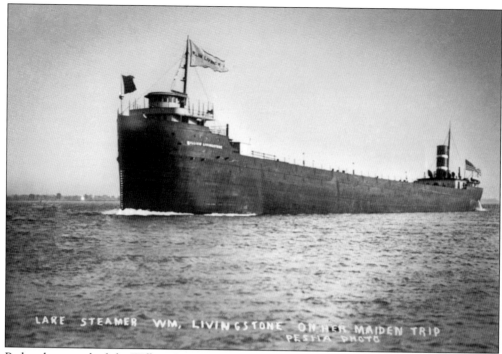

LAKE STEAMER WM. LIVINGSTONE ON HER MAIDEN TRIP
PESHA PHOTO

Pesha photographed the *William Livingstone* passing Marine City on her maiden voyage in 1908. She was built that year by the Great Lakes Engineering Works of Ecorse for the Mutual Steamship Company of Detroit. In June 1909, the steel-hulled *Livingstone* sideswiped the wooden-hulled *W.P. Thew* while in a thick fog about three miles off of Thunder Bay Island in Lake Huron. The *Thew*'s hull sustained massive damage and sank in 30 minutes. Surprisingly, the *Livingstone* did not stop to assist because Capt. D.P. Crane believed that the *Thew* was not damaged. Her crew of 11 was eventually rescued by the passing steamer *Mary C. Eiphicke.*

The *Allegheny* was a 5,000-ton freight steamer launched in Wyandotte, Michigan, by the Detroit Ship Building Company in 1910, constructed for the Erie and Western Transportation Company's Anchor Line that was owned by the Pennsylvania Railroad. She was practically a duplicate of the steamer *Conemaugh.* Pesha misspelled the ship's name on this card, which was not uncommon for his postcard captions.

The *William C. Agnew* was built by the American Ship Building Company of Lorain, Ohio, in 1911 for the Buffalo Steamship Company of Cleveland. She enjoyed a long, useful life and sailed on the Great Lakes until 1974.

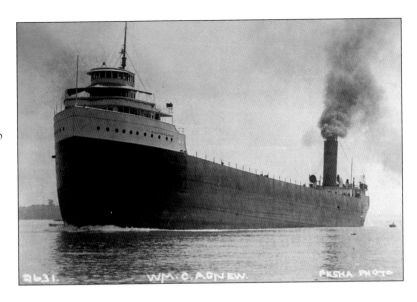

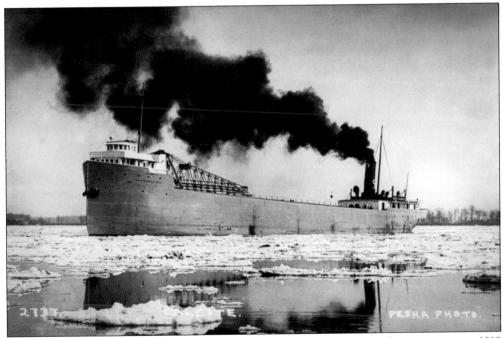

This photograph of the Great Lakes steamer *Calcite* was featured in an advertisement in a 1918 issue of *Beeson's Marine Directory*, published six years after Louis's death. His wife, Lena, continued the business in Marine City until 1920, placing the advertisement for the Pesha Art Company, "Marine Photography a Specialty, Mrs. L. Pesha, Proprietress." It is unclear whether she carried on the work of her husband by taking new photographs herself, if she hired other photographers to take new pictures, or if she simply sold the pictures that Louis took before his death. Chances are slim that he photographed the *Calcite*, as he died the same year that the vessel was built by the Detroit Ship Building Company in Wyandotte, Michigan, in 1912.

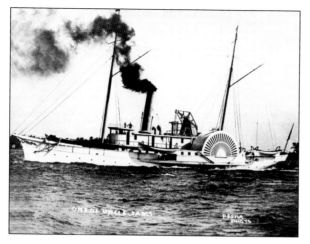

Many types of ships passed by Pesha's shop on the St. Clair River, including vessels owned by the US government. "One of Uncle Sam's," the *William P. Fessenden*, was originally built of wood in 1866. In 1884, the Union Dry Dock Company of Buffalo placed her engine in an iron hull. She was used by the US Treasury Department as a revenue cutter from 1884 until 1909. The government sold her to George Craig of Toledo, Ohio, in 1909, and she was rebuilt as a passenger steamer and renamed the *Chippewa*.

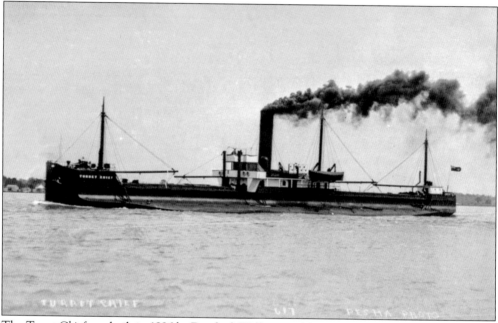

The *Turret Chief* was built in 1896 by Doxford, William and Sons, Limited in England for trading on the Suez Canal. She was one of a new breed of vessel designed to reduce canal fees, which were based on flat deck space. The design reduced horizontal deck space by sloping the ship's sides inward to create a narrow deck but preserving cargo space below. The Canadian Lake and Ocean Navigation Company brought her to the Great Lakes in 1907. She had three sister ships on the Lakes: the *Turret Cape*, the *Turret Crown*, and the *Turret Court*. In 1913, she was sold and in 1914 renamed the *Vickerstown*. Later requisitioned for service in World War I and renamed the *Jolly Inez*, she served as a munitions carrier between Britain and Archangel. In 1927, she was stranded in fog on Saddlebag Island in False DeTour Channel on Lake Huron. She was then salvaged by the T.L. Durocher Company of DeTour, Michigan, renamed the *Salvor*, converted to a steel barge, and returned to service on the Great Lakes in 1922. In September 1930, she broke away from the tug *Richard Fitzgerald* during a storm on Lake Michigan. She foundered in 25 feet of water, almost three miles north of Muskegon, and took her crew of five to the bottom to meet their final resting place.

The USS *Dubuque*, Gunboat No. 17 was launched in 1904 to protect American Atlantic coastal waters. In 1911, she was decommissioned for use as a training ship by the Illinois Naval Militia. In 1915, she was re-commissioned and assigned to the Mining and Minesweeping Division in the Atlantic Fleet. During World War II, she was used to train merchant-ship, armed-guard crews in the Chesapeake Bay. Pesha most likely photographed the *Dubuque* during her time with the Illinois Naval Militia.

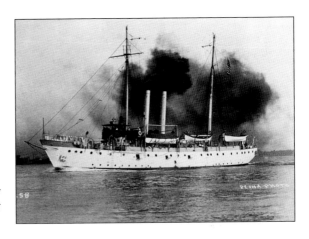

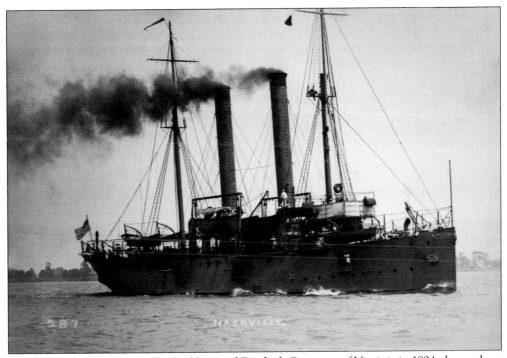

Built by the Newport News Shipbuilding and Drydock Company of Virginia in 1894, the gunboat USS *Nashville* (PG-7) was commissioned by the US Navy to join the North Atlantic Fleet. War with Spain was imminent after the sinking of the USS *Maine*, and she was quickly ordered to the Caribbean. In 1898, she captured four Spanish vessels and assisted in cutting the undersea telegraph cable off the shore of Cuba. Sent by Teddy Roosevelt in 1903, she was the first American warship to support the Panamanian Revolution. In 1907, the *Nashville* caused an international incident when she was sent to the Great Lakes through the St. Lawrence Seaway without permission from the Canadian government. During World War I, she served as a coastal patrol and convoy escort off North Africa until being decommissioned in 1918.

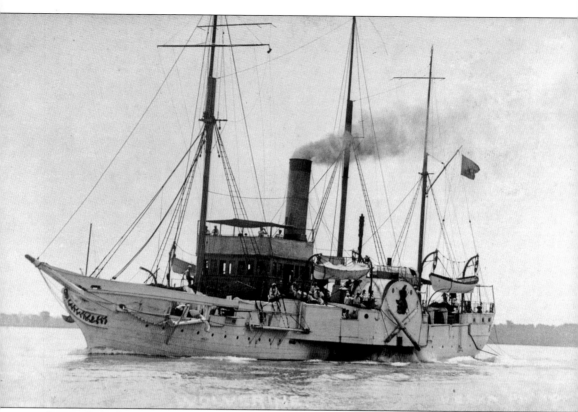

Originally built in 1842, the USS *Michigan* was the first iron-hulled vessel in the US Navy. She was armed with a 30-pound Parrott rifle, five 20-pound Parrott rifles, six 24-pound smoothbores, and two 12-pound boat Howitzers. In 1853, she was rammed in southern Lake Huron by timber pirates in the wooden-hulled *Buffalo*, who had been pillaging timber from private lands along the coast. The *Michigan* was unscathed, but the *Buffalo* was badly damaged and the timber pirates were captured and arrested. She served in the Great Lakes during the American Civil War, patrolling the United States and Canadian border to protect shipping interests from the Confederates, although serious threats never materialized. She was renamed the USS *Wolverine* in 1905 so a new battleship could be named *Michigan*. She was decommissioned in 1912 and lived out the rest of her career with the Pennsylvania Naval Militia service until 1923 when a connecting rod of her port cylinder broke.

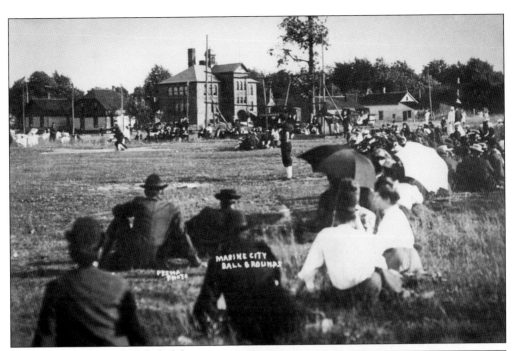

Pesha also photographed daily life in Marine City. Taken from the outfield, this image shows a large crowd gathered to watch America's favorite pastime at the Marine City Ball Grounds. Judging by the uniforms, the game could have been between teams sponsored by local factories or, perhaps, between barnstorming baseball teams that travelled to nearly every state in the Union. The Second Ward School is seen in the background.

This picture postcard titled "My Catch on the River St. Clair" features a nice stringer full of lake perch. It is easy to imagine that the prospect of a monumental take like this was a great way to advertise tourism of the area.

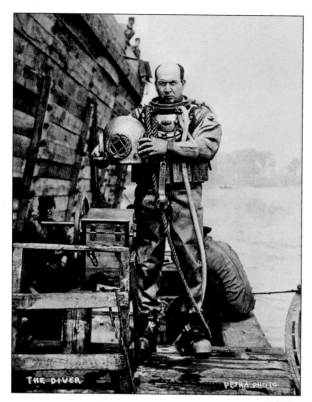

THE DIVER PESHA PHOTO

Pesha photographed many aspects
of life all around the River District.
He caught this magnificent
series of photographs of "The
Diver" and his crew preparing to
repair a ship below the waterline
somewhere on the St. Clair River.

THE DIVER PESHA PHOTO

Hard-hat divers were also used to survey and
salvage shipwrecks. The standard diving
dress consisted of a copper, brass, or bronze
helmet, an airline or hose called an umbilical
that was connected to a surface-supplied
diving pump, a canvas suit, and boots.

The suits were heavy, weighing up to 200 pounds. An important part of the equipment was lead weights, generally worn on the chest, the waist, and boots to counteract the buoyancy of the helmet and diving suit. Considering the weight of bulky tools, the challenging environment of a strong current, cold water, and poor visibility conditions, it becomes clear that this work required a diver to have the strength and endurance that most did not possess.

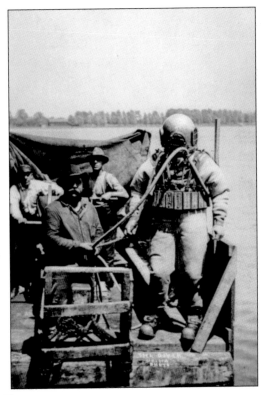

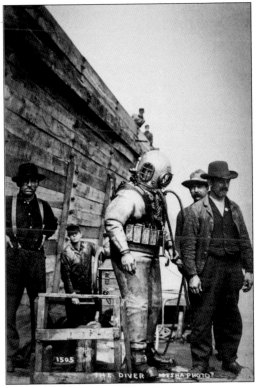

Self Contained Underwater Breathing Apparatus (SCUBA) would not be invented for another 40 years from the time this picture was taken.

Pesha photographed the "Indian Band" at Walpole Island, a close neighbor of Marine City's, just downriver on the Canadian side. Walpole Island is inhabited by the Chippewa, Ottawa, and Potawatomi peoples of the Walpole Island First Nation, who call it Bkejwanong, which translates to "where the waters divide."

In one of his many travels, Pesha photographed the tourist boat *Maid of the Mist I* at Niagara Falls. The *Maid* sailed from 1885 through 1955, carrying tourists through the mists of Horseshoe Falls. Also known as the Honeymoon Bridge or Fallsview Bridge, the Upper Steel Arch Bridge can be seen in the background. Constructed in 1897, the bridge was built to carry streetcars operating on the Great Gorge Scenic Railway. Until it collapsed in a severe ice storm in January 1938, it was the fourth bridge on that site in 50 years. It was replaced with the Rainbow Bridge, which still stands today.

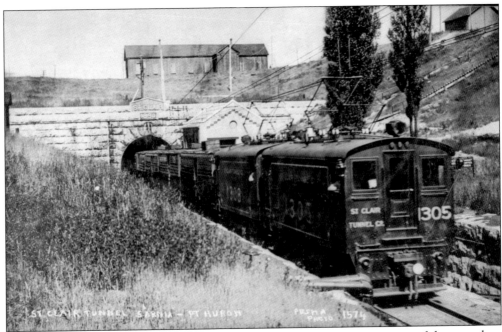

Pesha photographed these St. Clair Tunnel Company electric cars coming out of the tunnel on the Sarnia, Ontario, side of the river. The company was a subsidiary of the Grand Trunk Railway, which connected with the Grand Trunk Western Railroad. The tunnel was the first subaqueous tunnel built in North America that could fit a train, and it connected Port Huron with Sarnia under the St. Clair River. The St. Clair Tunnel Company opened the tunnel in 1891, with steam locomotive freight trains to be the first in service. Passenger trains were put in service the following year; however, the worry of suffocation if a train should stall midway through the tunnel prompted a change to electric-powered locomotives in 1908. The tunnel measured 6,025 feet, had a diameter of 19 feet, 10 inches, hosted a single, standard-gauge track, and cost $2.7 million to build. For its time, the tunnel was an engineering marvel.

Venturing all around the Great Lakes region, Pesha was fond of photographing trains and stations. The depot at Port Huron was built in 1891. Note the catenary, or overhead wires, which was installed in 1907 to run electric engines. His railroad depot postcards are especially valuable amongst collectors.

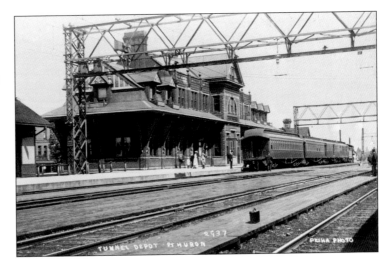

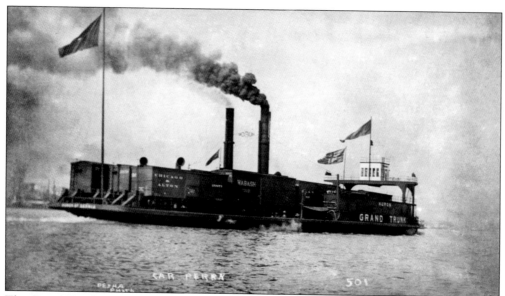

The Grand Trunk Western Railroad operated car ferries across the St. Clair River between Port Huron and Sarnia before the St. Clair River Tunnel was completed. It discontinued the ferries around 1891 when the tunnel opened but reinstated them in 1971 because larger rail cars had clearance issues in the tunnel.

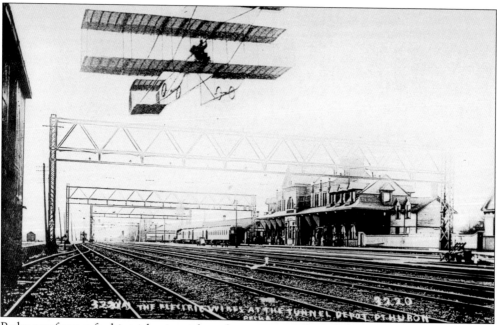

Pesha was famous for his trick, gimmick, or fantasy postcards, and they were quite popular. This card offers a unique twist on one of his favorite subjects by combining a photograph of the St. Clair River Tunnel Depot and an "aeroplane" or a glider, which was obviously added after he took the original photograph. Pesha would have sold this postcard to take advantage of the public's fascination with the early American pioneers of flight, the Wright Brothers. Orville and Wilbur Wright made the first sustained, controlled, and manned flight at Kill Devil Hills, near Kitty Hawk, North Carolina, on December 17, 1903.

This is another example of Pesha's trick or fantasy postcard photography called "Corn grown in Ontario, Canada." The old man's back must have really ached under the weight of this blue ribbon–winning ear of corn!

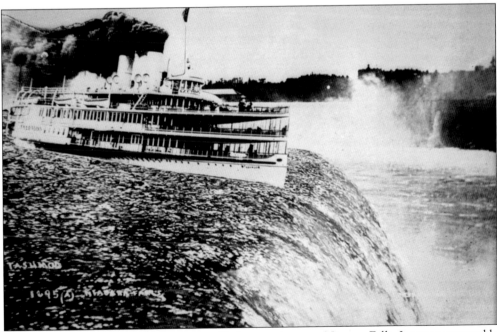

This card features the passenger steamer *Tashmoo* going over Niagara Falls. It seems reasonable to imagine that he photographed the falls on the same trip he photographed the *Maid of the Mist I*. The trick-image development process must have been complex, as Pesha used dry-plate, glass-negative photography.

Another example of Pesha's trick photography, this image shows the passenger excursion steamer *City of Toledo* being "towed" by a bi-plane on "The River St. Clair." The *City of Toledo* was built in 1891 by the Craig Ship Building Company of Toledo, Ohio. She was taken to Chicago for the World's Fair in 1893 and ran from Detroit to Port Huron, Michigan, from 1895 to 1916. This picture shows her before she was lengthened and given a second stack in the winter of 1916–1917.

"The Kind of Ducks We See at the St. Clair Flats" is another Pesha trick photograph, with the mallard clearly being added to the original image later. Perhaps owing to its popularity of the day, the *Tashmoo* was a popular subject for Pesha to photograph and for him to use in his illusionary or fantasy postcards.

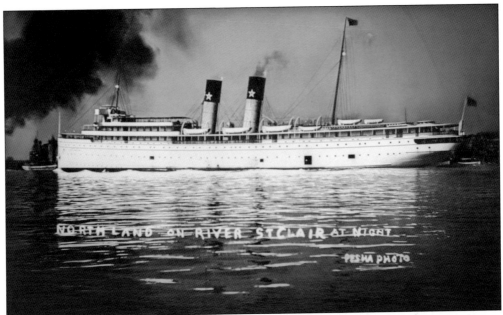

Although other photographers were engaged in nighttime photography during this period, it is not clear if Pesha did the same. Regardless, this is another trick photograph made to look like a nighttime shot. The subject of this photograph, the *Northland*, was built by the Globe Iron Works of Cleveland in 1895 for the Northern Steamship Company of Buffalo. The *Northland* was a fast passenger steamship liner that made weekly sailings between Chicago and Buffalo with stops in between, making the 929-mile trip in three days.

Another of Pesha's trick cards, this shows the tugboat *George Nelson* appearing to do the impossible: towing a giant cord of Redwood down the St. Clair River.

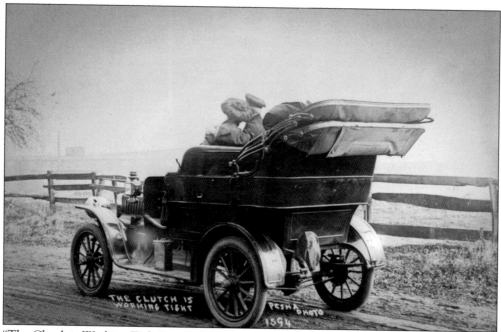

"The Clutch is Working Tight" is one of Pesha's many romantic themes, with a couple snuggled together in a 1910 Ford Model T Touring Car.

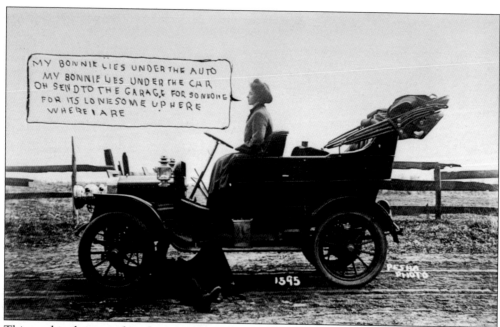

This card is the second in the series that features the same couple as "The Clutch is Working Tight." Showcasing the same 1910 Ford Model T Touring Car, the caption reads, "My Bonnie lies under the auto, My Bonnie lies under the car, Oh send to the garage for someone, for its lonesome up here where I are."

Another of Pesha's romantically themed cards, "Making Hay while the Sun Shines" was taken just north of town on River Road sometime in the early 1900s.

Pesha's subjects included everything one could imagine, from the maritime traffic on the St. Clair River, to train depots, to lovers courting, to this mother hog and her piglets in "Dinner From 1 to 12 Warm Lunch at All Hours."

"Every Man For Himself and the Devil for Them All at Marine City" speaks for itself.

BIBLIOGRAPHY

Biographical Memoirs of St. Clair County, Michigan: To Which Is Appended a Comprehensive Compendium of National Biography; Memoirs of Eminent Men and Women in the United States. Logansport, IN: B. F. Bowen, 1903.

History of St. Clair County, Michigan: Containing an Account of Its Settlement, Growth, Development and Resources, an Extensive Sketch of Its Cities, Towns and Villages, Their Improvements, Industries, Manufactories, Churches, Schools and Societies, Its War Record, Biographical Sketches, Portraits of Prominent Men and Early Settlers, the Whole Preceded by a History of Michigan, and Statistics of the State. Chicago: A. T. Andreas and Company, 1883.

Jenks, William L. *St. Clair County, Michigan, Its History and Its People: A Narrative Account of Its Historical Progress and Its Principal Interests.* Chicago: Lewis Publishing Company, 1912.

Mansfield, John Brandt. *History of the Great Lakes,* vol. 2. Chicago: J.H. Beers & Co., 1899.

McElroy, Frank. *A Short History of Marine City, Michigan.* Marine City, MI: Marine City Rotary Club, 1980.

Moore, Charles. *History of Michigan.* Chicago: Lewis Publishing Company, 1915.

Preliminary Historic District Study Committee Report. Marine City, MI: The City Hall of Marine City, Michigan, 2008.

Ward, Emily, and Ann Tompert. *The Way Things Were: An Autobiography of Emily Ward.* Marine City, MI: Newport Press, 1976.

A Wind Gone Down: Smoke into Steel. Lansing, MI: Michigan History Division, Department of State, 1978.

Discover Thousands of Local History Books Featuring Millions of Vintage Images

Arcadia Publishing, the leading local history publisher in the United States, is committed to making history accessible and meaningful through publishing books that celebrate and preserve the heritage of America's people and places.

Find more books like this at
www.arcadiapublishing.com

Search for your hometown history, your old stomping grounds, and even your favorite sports team.

Consistent with our mission to preserve history on a local level, this book was printed in South Carolina on American-made paper and manufactured entirely in the United States. Products carrying the accredited Forest Stewardship Council (FSC) label are printed on 100 percent FSC-certified paper.

MADE IN THE USA